Rescue
CATS

PORTRAITS AND STORIES

Susannah Maynard

AMHERST MEDIA, INC. ■ BUFFALO, NY

This book is dedicated to my mother, without whom not only would I not be here, but without whom I would not have my deep love for animals nor my creative abilities. I will always love and miss you, mom. This book is also dedicated to all the cats I've loved—past, present, and future.

Published by:
Amherst Media, Inc.
PO BOX 538
Buffalo, NY 14213
www.AmherstMedia.com

Publisher: Craig Alesse
Senior Editor/Production Manager: Michelle Perkins
Editors: Barbara A. Lynch-Johnt, Beth Alesse
Acquisitions Editor: Harvey Goldstein
Associate Publisher: Katie Kiss
Editorial Assistance from: Carey A. Miller, Roy Bakos, Jen Sexton-Riley, Rebecca Rudell
Business Manager: Sarah Loder
Marketing Associate: Tonya Flickinger

ISBN-13: 978-1-68203-344-9
Library of Congress Control Number: 2017963173
Printed in the United States of America
10 9 8 7 6 5 4 3 2 1

AUTHOR A BOOK WITH AMHERST MEDIA!

Are you an accomplished photographer with devoted fans? Consider authoring a book with us and share your quality images and wisdom with your fans. It's a great way to build your business and brand through a high-quality, full-color printed book sold worldwide. Our experienced team makes it easy and rewarding for each book sold—no cost to you. E-mail **submissions@amherstmedia.com** *today!*

www.facebook.com/AmherstMediaInc
www.youtube.com/AmherstMedia
www.twitter.com/AmherstMedia

CONTENTS

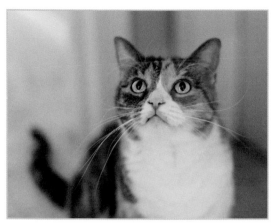

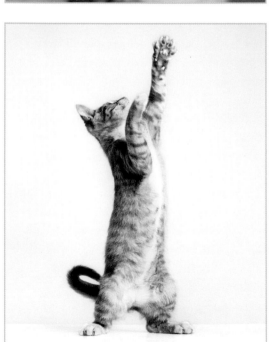

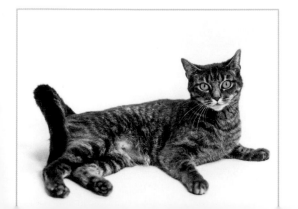

ABOUT THE AUTHOR

Susannah Maynard is a lifelong animal lover, animal rescue advocate, and pet photographer. Long before she picked up her first camera, her mother's childhood Kodak Brownie, she captured images of the world around her with a pad of paper and a box of crayons. Her creativity and love of animals was instilled in her at a young age by her mother. Growing up in a house full of cats, she never lacked for subjects for both her drawing and photography.

After trying a variety of careers, from fundraising to publishing, Susannah was at a career crossroads when, in 2011, she adopted her heart dog, Mr. Bojangles, and discovered there was such a profession as pet photographer.

Deciding to turn her love of both photography and pets into a career, Pet Love Photography was born.

Susannah has spent the last several years honing her skills as a pet photographer by photographing hundreds of rescue and client pets. She primarily works on location to make sure that her pet subjects are as comfortable as possible in environments that are familiar to them (especially important for cats). Susannah is a member of Professional Photographers of America and HeARTs Speak.

When not out photographing other people's pets or donating her time to rescue organizations or other pet charities, Susannah spends time with her own pet family: her rescue cat Diana, and three rescue dogs, Stella, Mr. Bojangles, and Paco.

To learn more about Susannah Maynard, visit:

www.petlovephotography.com
www.facebook.com/petlovephotography
www.twitter.com/PetLovePhotos

INTRODUCTION

I t's a fact that most cats and kittens that enter shelters across the country, and around the world, never make it out alive. Statistically speaking, an estimated 70 percent of cats that enter facilities are euthanized each year. As a lifelong animal lover and someone who grew up in a house full of cats, this is a heartbreaking statistic. This doesn't even take into account the feral cats who live their short and hard lives on the edges of society. It's estimated that about half the cat population in the United States is feral. If a feral cat is brought to a shelter, it almost certainly means death, as the majority of feral cats have been left to fend for themselves their entire lives or were born into the feral life, and therefore are not socialized. However, just because a cat is feral does not mean that it can't be socialized, nor that it can't be a great pet.

This book focuses on rescue cats and kittens and their stories. As you will see, there are many ways that a cat becomes a rescue and, very often, they are rescued by the person they end up living with. Stray cats that become house cats are rescue cats just as much as cats that are adopted from rescue organizations. In fact, according to the American Pet Products Association (APPA), almost as many household cats are adopted as strays as those adopted from shelters or rescues. The cats and kittens featured in this book come from rescues or were adopted as strays. Even the cats in rescues are often found as strays.

My entire life, I've lived with cats. In fact, there have only been a few years when I have not had a cat (or multiple cats). My parents had cats before they had me. From a young age, I experienced caring for neighborhood strays, as my mom would feed them and we would play with them in the backyard. I remember the devastation I felt when, while still in kindergarten, I came home to find out that one of the neighborhood strays had been hit by a car and killed. My mom and I buried the little gray kitty; that was my first experience with an animal's death, and a hard lesson as to the perils that stray cats deal with.

Growing up, we took in a neighborhood stray when she became pregnant. Patches was my first experience with a mama cat and her kittens. They were so tiny and fragile. She had six of them: Junior, Morris, Butterball, Foggy, Tubby Bottom, and Scaredy Cat. Patches and her kittens, Junior and Morris, lived long lives with us; her other kittens were adopted into loving homes, but I've never forgotten them, nor their antics, to this day. There would be other strays after this. It wasn't until I was out of college that I adopted my first cat from a shelter. Since then, my cats have all been adopted from rescues, but I would not hesitate to help a stray cat or kitten in need of a home.

Because I like to give back to rescues and other pet-related organizations, not only with my photography, but financially when I can, I am donating a portion of the proceeds from the sale of this book to the following organizations: Cincinnati Cats; Jake's Place Cat Rescue in the San Francisco Bay Area; and Pets in Need of Greater Cincinnati, a non-profit veterinary clinic that provides both medical and food assistance for pets in low-income homes.

1 KITTENS

KATE

(below) Kate, the tortie/calico pictured here at seven weeks, came to rescue as a tiny kitten along with her four siblings (William, Harry, George, and Charlotte) and mom, Diana. Kate and her siblings were around six weeks old when they arrived in rescue in Ohio from a rural shelter in eastern Tennessee. Kittens can't be spayed or neutered until they reach a certain weight, and these kittens spent about four weeks in foster care prior to their date with the vet. Kate was the first of the litter to be adopted; she went to a family with two other cats and a small dog. Kate, now named Daisy, is a big, happy girl who rules the roost in her new home.

HARRY

(following page) Harry, along with his siblings Kate, William, George, and Charlotte, made up "The Royals" litter. He came to rescue in Ohio along with his mom, Diana, from a shelter in rural Tennessee. Unfortunately, being an adorable kitten is not protection enough from euthanasia. Without a foster and rescue stepping up to take this little feline family, they would have met a sad fate. Fortunately, these kitties were saved to play another day, and Harry eventually found his forever family after a few months in rescue.

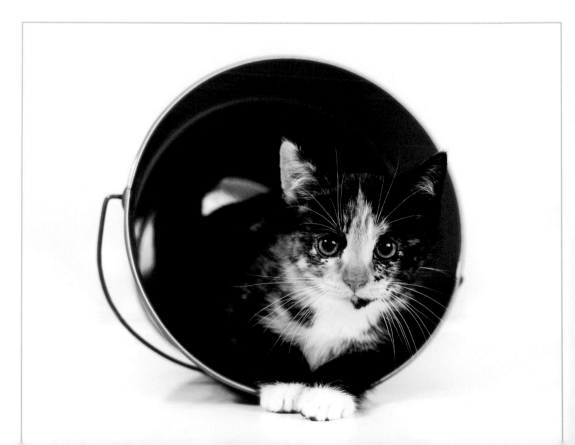

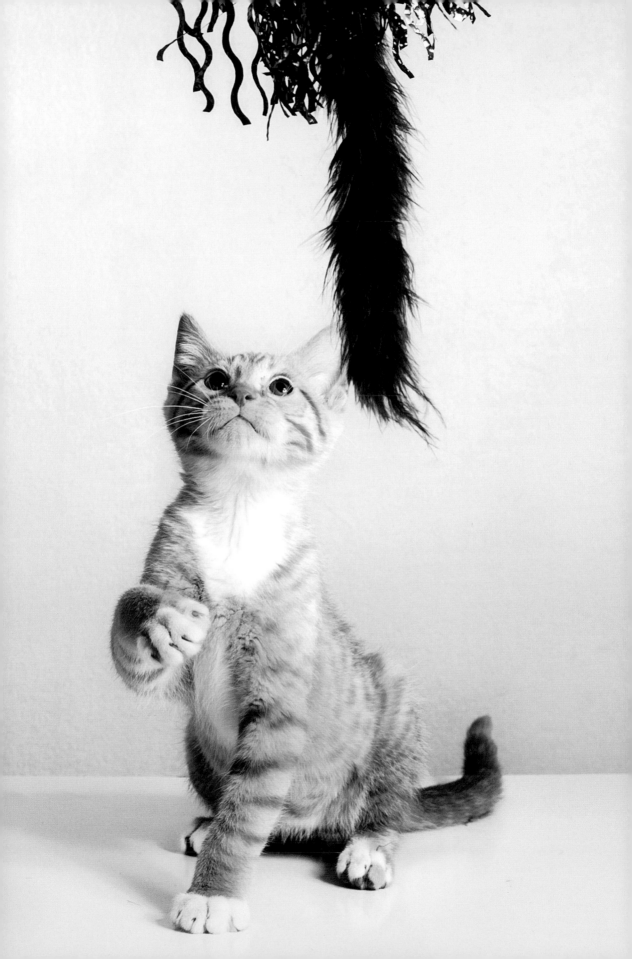

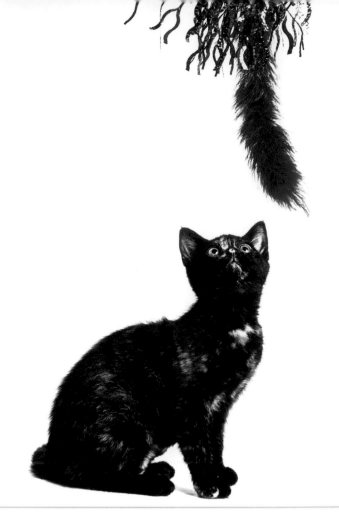

CHARLOTTE

(above and following page) Charlotte, also one of "The Royals" litter, along with her siblings Kate, William, Harry, George, and mom, Diana, came to a rescue in Ohio from a rescue in rural Tennessee. Charlotte was the shyest of the bunch and also a full tortoiseshell like her mom. Charlotte was a sweet little girl who could hold her own with her brothers' roughhousing. Of all the kittens, she was also the one who liked to hang out with her mom the most. Charlotte lucked into getting adopted. Her adopter had wanted another kitten, and because the first kitten wasn't socialized very well, Charlotte won his heart. It's very important that kittens are well-socialized when they are young, as it makes for friendly, well-adjusted adult cats. She was the second of the litter to be adopted, at a little over fifteen weeks old.

It's very important that kittens are well-socialized when they are young, as it makes for friendly, well-adjusted adult cats.

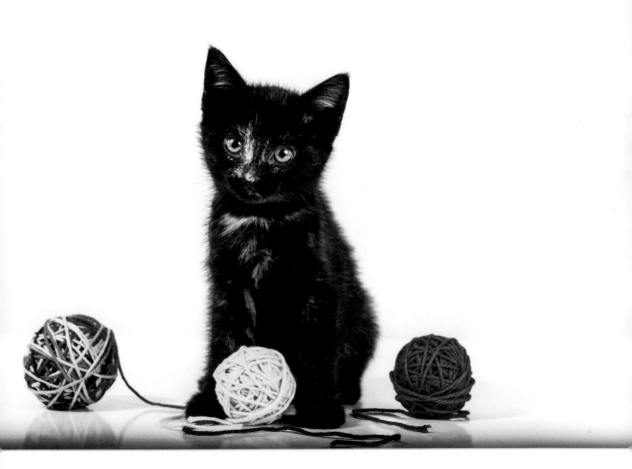

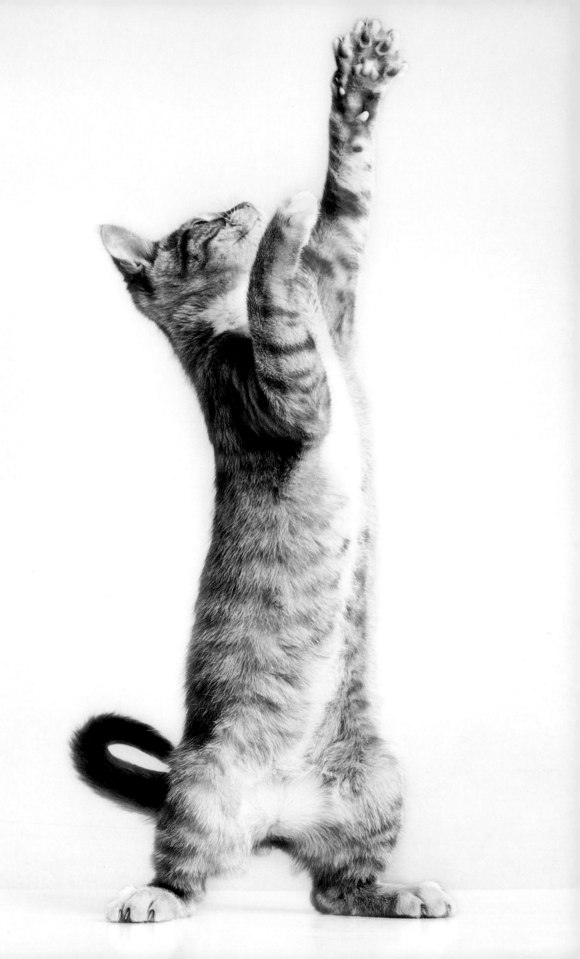

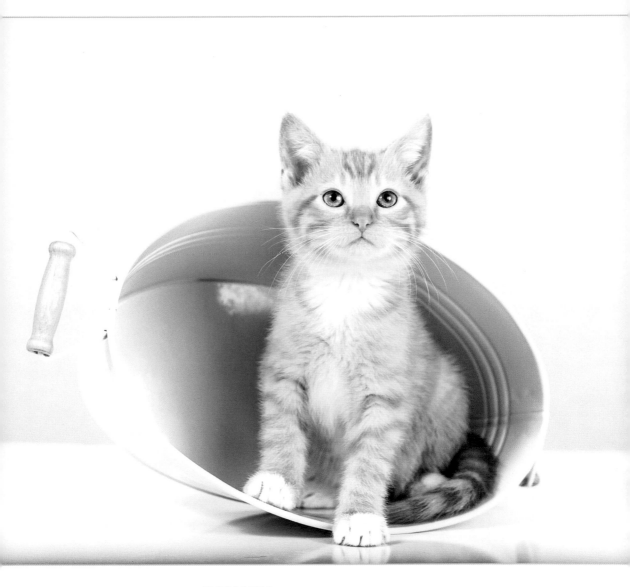

WILLIAM

William, along with his "royal" siblings, came to rescue from a shelter in rural Eastern Tennessee.

(previous page and above) William, along with his "royal" siblings, came to rescue from a shelter in rural Eastern Tennessee. He and his brother George were the biggest of the litter and loved wrestling with each other. William was adopted with his brother George after several months in rescue. William is pictured on the previous page at three months old and above at seven weeks.

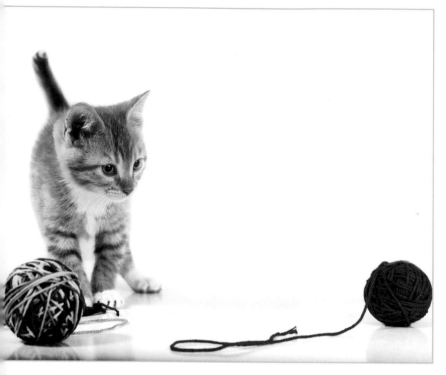

GEORGE

(top and bottom) George, also featured in the top image on the cover, was another of "The Royals" litter. He was the biggest and the baddest of the boys. He was a fearless kitten with tons of personality. He absolutely loved running around and wrestling with his brothers. While all three of the boys in this litter were orange and white and hard to tell apart, George had the most white on him, so he was a little easier to identify than the other two boys. George was adopted with his sibling, William, after several months in rescue.

PONG

(following page) Pong, an orange tabby kitten, came to a no-kill shelter along with his sibling, Pablo. These delightful orange kittens were more fortunate than many kittens and cats. Pong was adopted into his forever home at a little over three months of age.

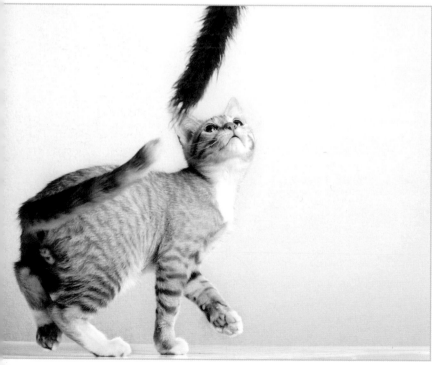

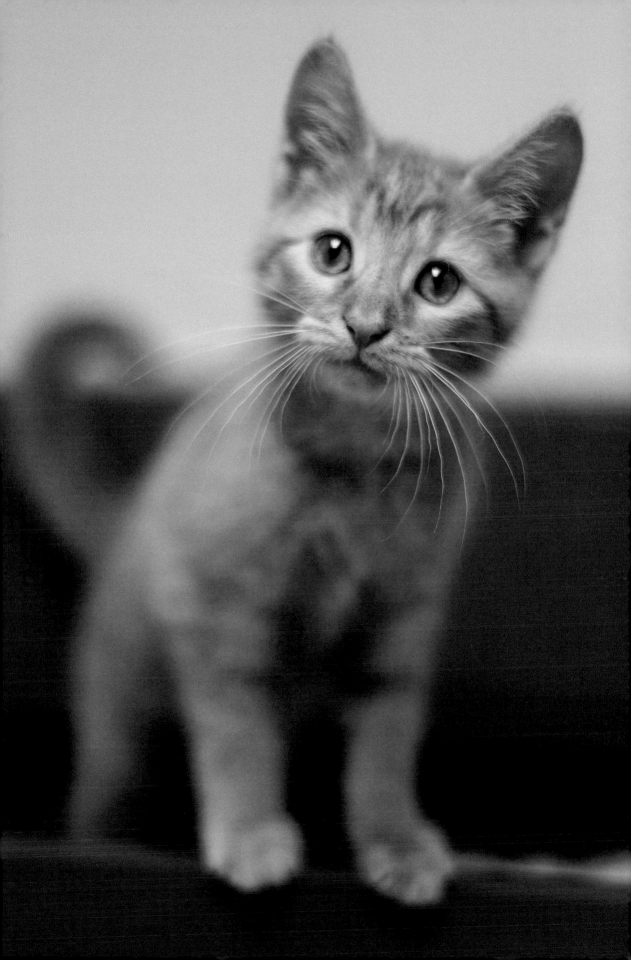

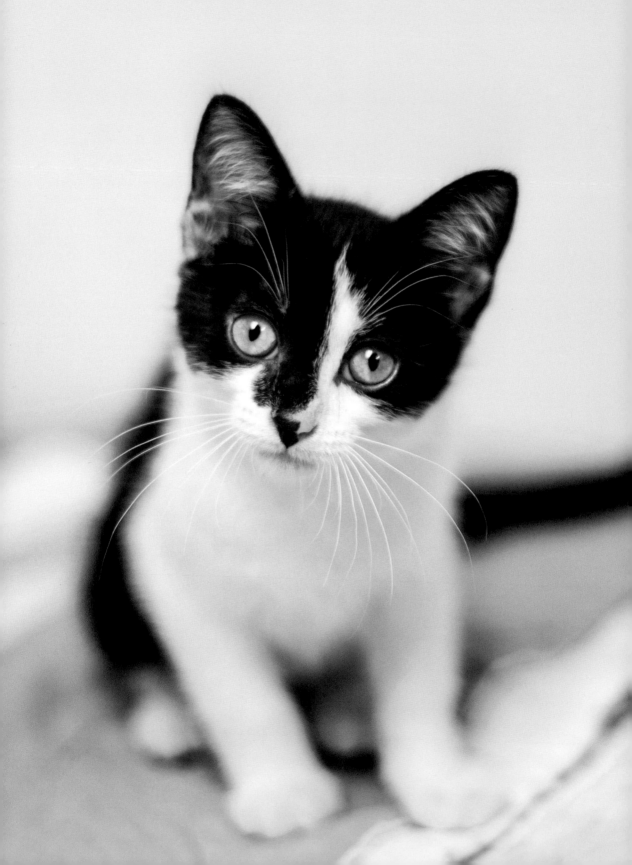

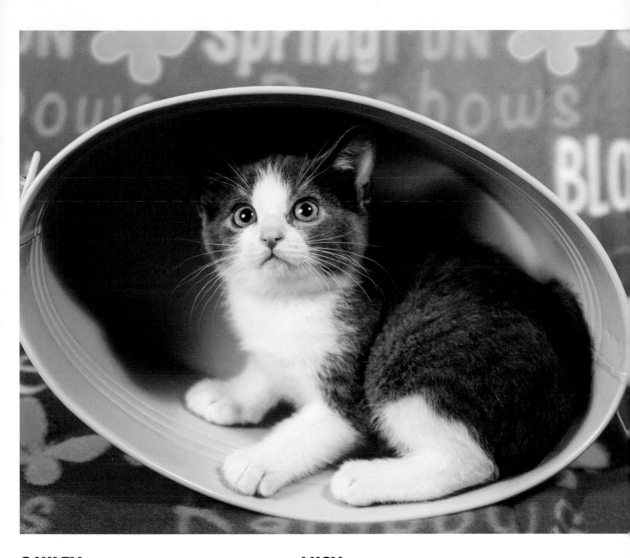

OAKLEY

(previous page) Oakley, a black-and-white domestic short-hair kitten, like many kittens, ended up in a shelter all by himself. It is common to find a lot of kittens in shelters and rescues from late spring to early fall, the period known as "kitten season," which typically falls from early spring to early fall. When the weather is warmer during the winter, kitten season can begin even earlier. Fortunately for Oakley, he ended up at a no-kill shelter and was adopted into his forever home at around three months of age.

LUCY

(above) Lucy and her siblings were born into rescue when their pregnant mom was saved from a rural high-kill shelter. They were lucky, because pregnant cats are often among the first to be euthanized. This fortunate little kitten found her forever family when she was just a few months old.

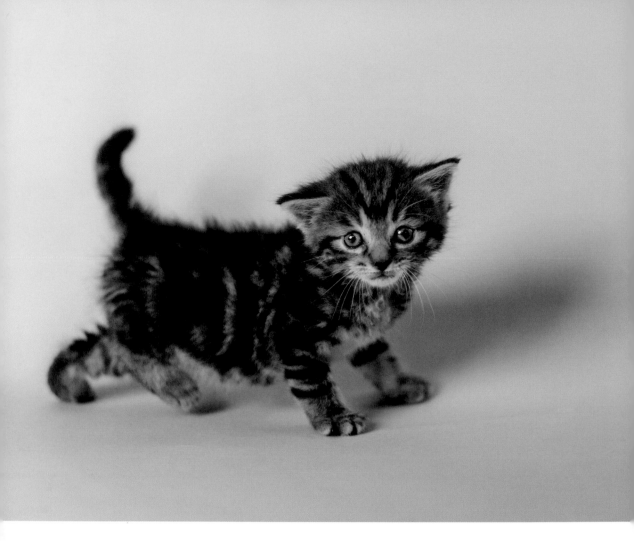

PLUIZIG

(above and following page) Pluizig was brought to a small Cincinnati-based rescue at just three weeks of age. He was bottle-fed until he was able to start eating regular kitten food. He is a spunky and fun little guy who wanted a forever playmate and home to call his own. Fortunately, his wishes came true!

Pluizig was brought to a small Cincinnati-based rescue at just three weeks of age.

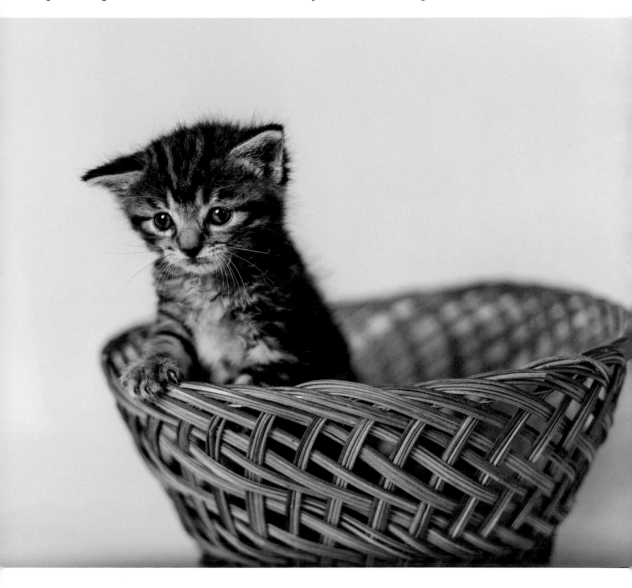

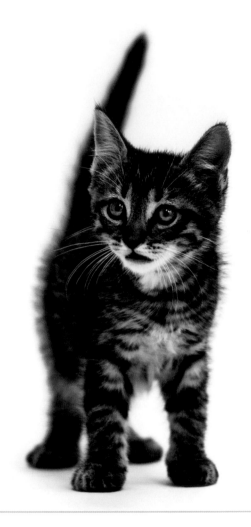

JOHN

Little tabby kitten John, along with his two siblings and his mom, Missy, ended up in a small Cincinnati-based rescue. John and his siblings were just three days old when they arrived at the rescue. Once the kittens were old enough to be adopted, John was quickly snatched up into his forever family.

JOYCE

Joyce and her siblings ended up in a small Cincinnati rescue along with their mom, Missy. She is an energetic kitten who likes to boss her brothers around. If there's trouble afoot, it's because of Joyce. This beautiful gray kitten was quickly adopted into a loving family.

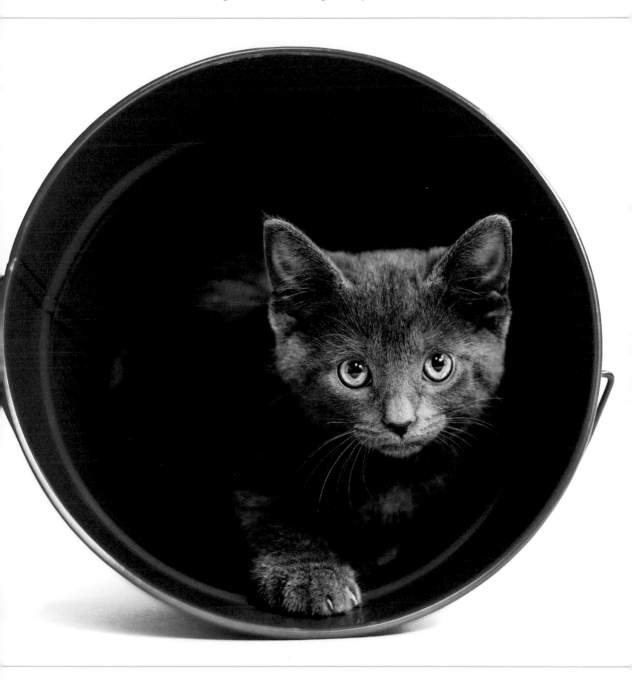

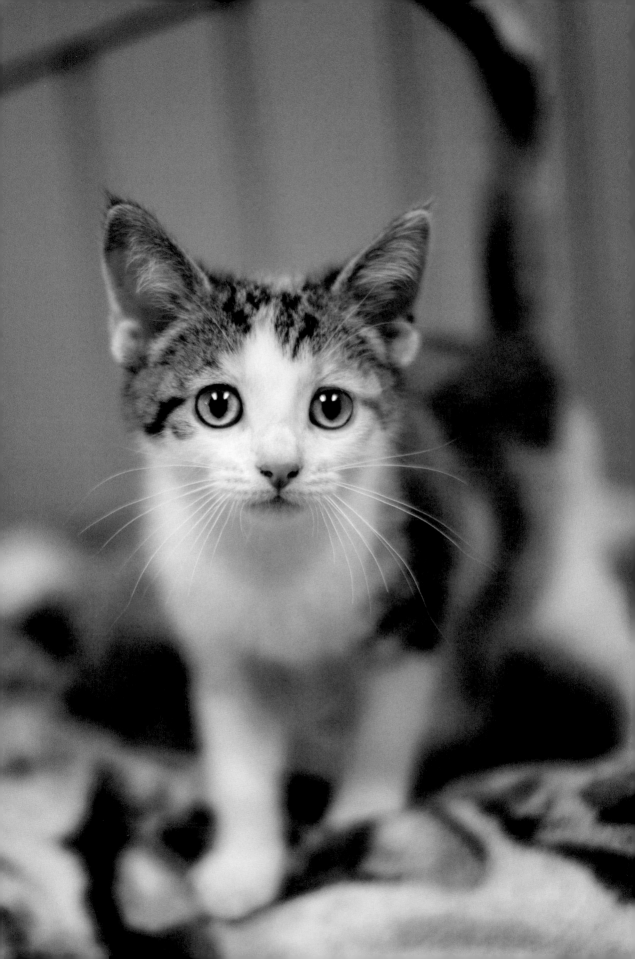

CABRIOLET

(previous page) Cabriolet, a female calico kitten, ended up in a no-kill shelter along with her sister, Cachet, a tortoiseshell kitten. Kittens are almost always adopted before adult cats. When kittens are especially unique in their coloring or markings, they are adopted even faster. Both Cabriole and her sister, Cachet, werc adopted quickly.

CACHET

(below) Cachet and her sister, Cabriolet, were two little kittens who ended up in a no-kill shelter during kitten season. During kitten season, the number of kittens within the shelter and rescue populations increases dramatically.

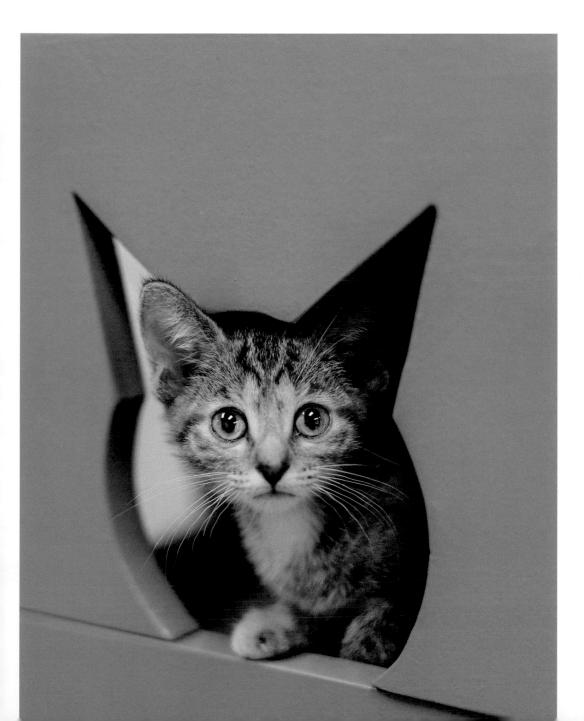

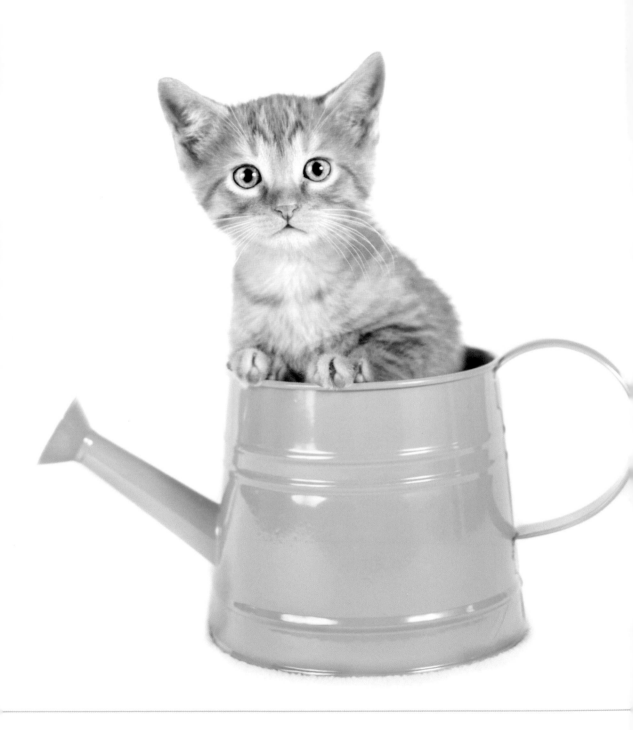

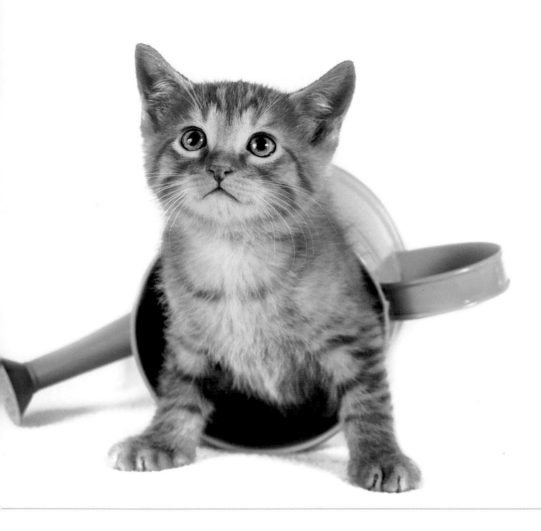

CHESTER

(previous page and above) Chester, along with his siblings, Buckeye, Olive, and Magnolia, were born into rescue when their pregnant mom, Willow, was saved from a rural high-kill shelter. Chester, an adorable orange tabby kitten, and his siblings were all adopted into their forever homes after a few months in rescue.

Chester, along with his siblings, Buckeye, Olive, and Magnolia, were born into rescue when their pregnant mom, Willow, was saved from a rural high-kill shelter.

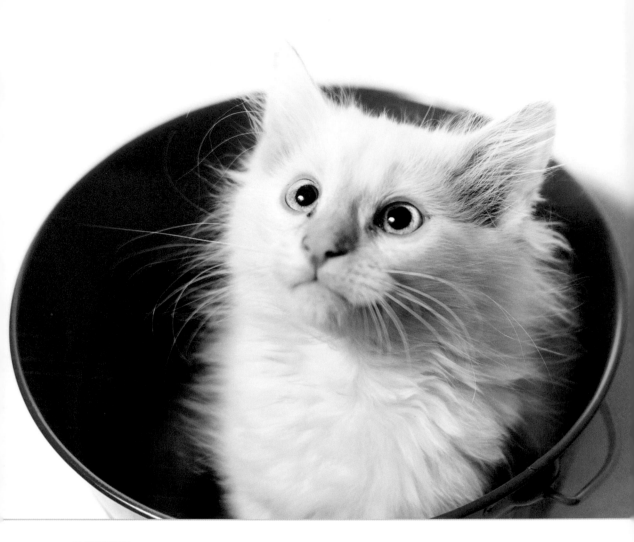

BRONX

Bronx, a fluffy male Siamese-mix kitten, was brought into
rescue with his mom and siblings from a rural high-kill
shelter. A playful little guy, he was adopted at three months
of age. All kittens are born with blue eyes, but most change
around six to seven weeks, with the exception of Siamese
and similar breeds.

QUEENS

Queens was a very special fluffy orange kitten, unusual in that most orange cats are male, not female. She was a sibling to Bronx and Jamaica who, along with their Himalayan mom, Brooklyn, came from a rural high-kill shelter.

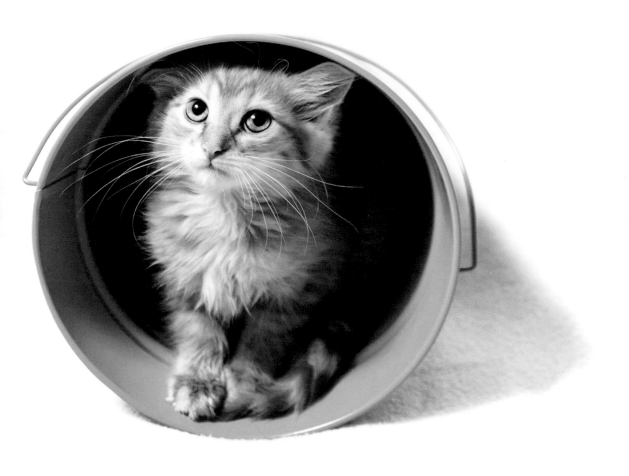

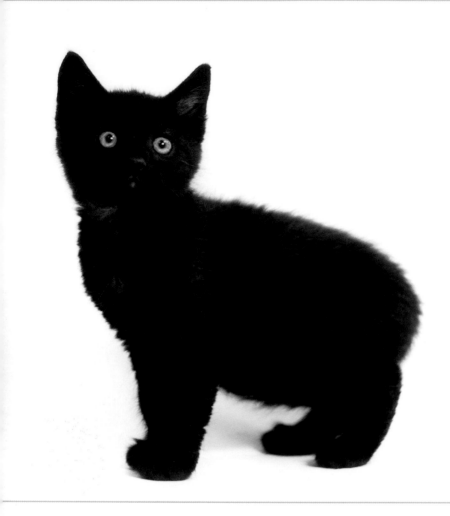

JEDI

(above) Jedi, as kittens often are, was found as a single kitten before being taken in by a small rescue. This playful little guy was only a couple of months old when he was adopted.

WILLOW

(following page) The no-kill rescue that took Willow in has a wonderful cat area with large rooms for felines to run around in. Willow was in a room with a number of other kittens so that they could play and have fun, as kittens are wont to do. Potential adopters can go into the different cat rooms to interact with the adoptables to find their perfect match. Luckily for Willow, she found her perfect family in short order and was quickly adopted.

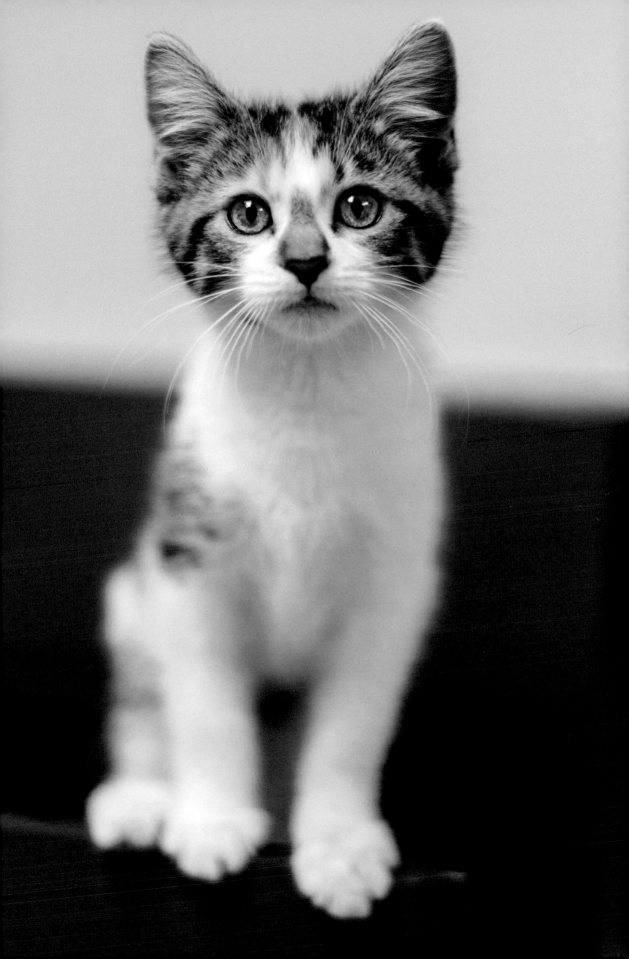

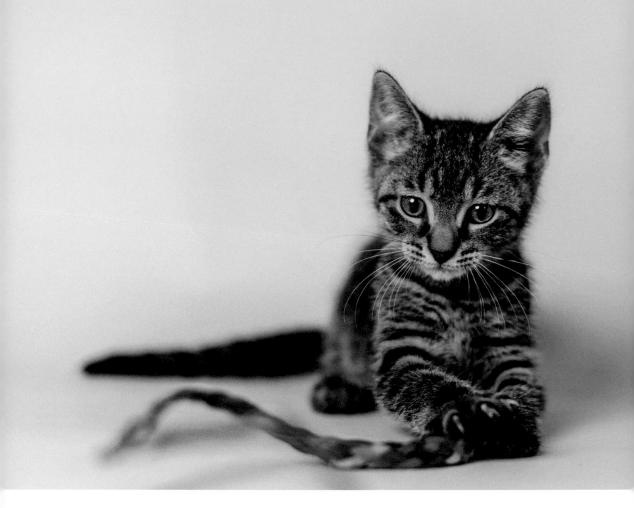

ZIGGY

(above) Ziggy is a fun-loving tabby kitten who came to rescue with his siblings and mother. He is extremely playful and constantly tries to get his siblings and mom to play with him. Ziggy and his siblings are all named after members of the Marley reggae family. Ziggy was adopted just as soon as he was old enough.

STEPHEN

(following page) Stephen, an adorable and playful orange tabby, sibling to Ziggy, was quickly snatched up from his Cincinnati-based rescue and adopted into a family with a young daughter. She has proven to be the perfect playmate for the rambunctious Stephen, and she's happy to oblige when he tires out and wants to cuddle!

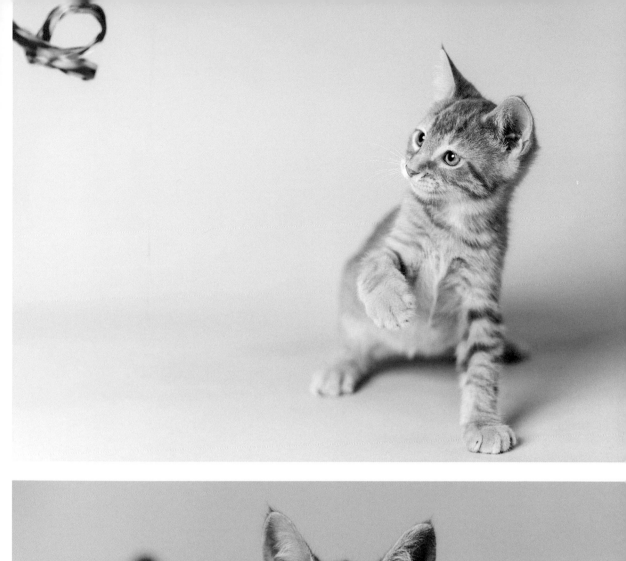
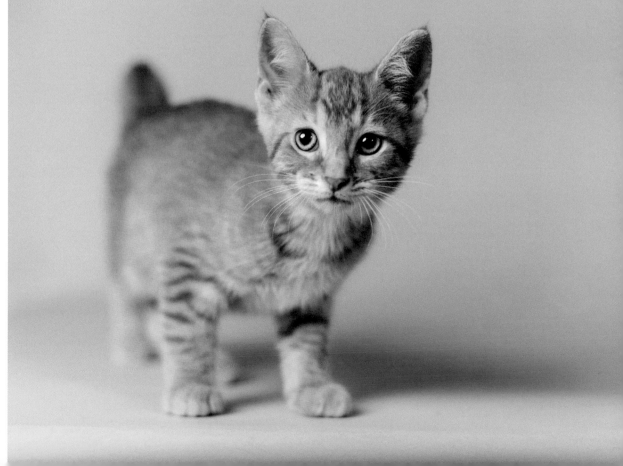

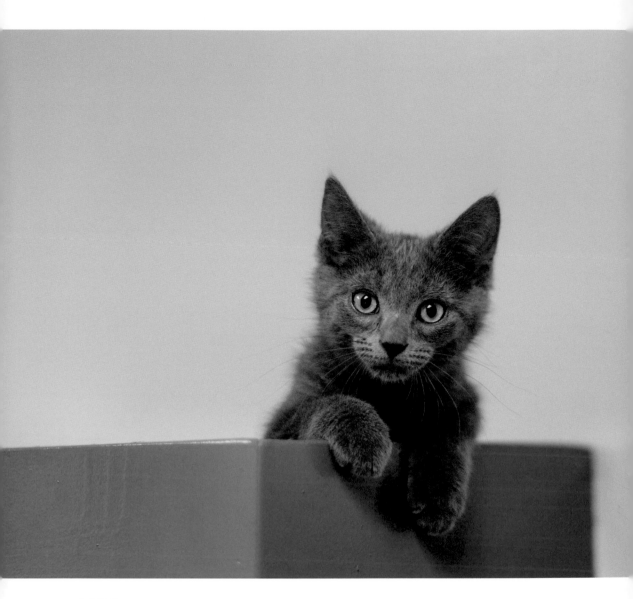

LARS

Lars, a handsome if somewhat shy gray kitten, was part of a litter that ended up at a no-kill animal shelter. He and his littermates had plenty of room to run around and interview potential families. Lars found the right candidate for his forever family and was adopted at a few months of age.

Lars found the right candidate for his forever family and was adopted at a few months of age.

JULIAN

Julian is a playful tabby kitten who loves nothing more than sneaking up on his siblings and even his mother. This playful little guy was quickly snatched up as soon as he was available for adoption.

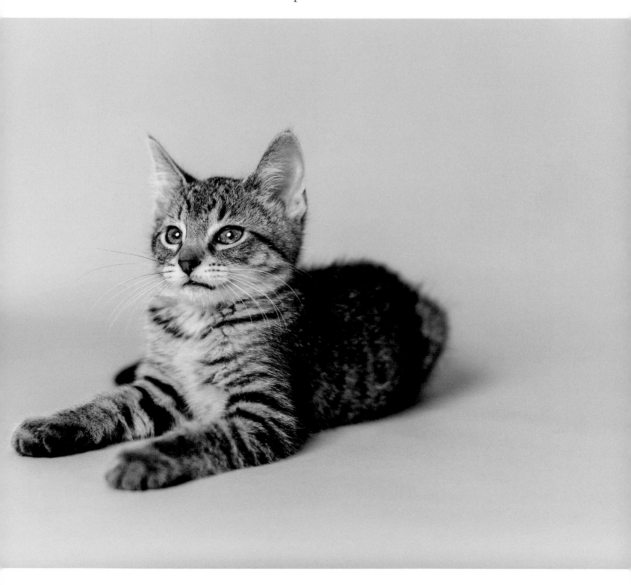

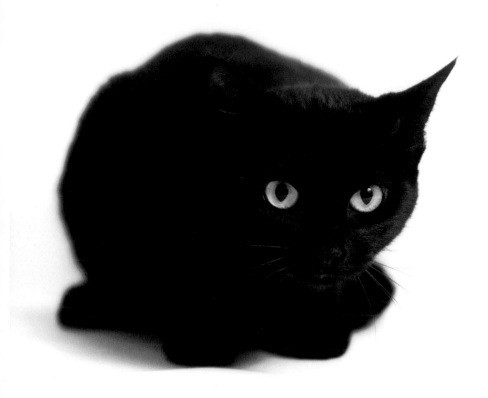

KIERRA

(above and following page) Kierra is a quiet black kitty who was unlucky enough to find herself homeless. Fortunately, she was taken in by a small rescue that helped this timid girl blossom. In the photo above, she is about eight months of age. Still in rescue a few months later *(following page image)*, you can see how she has matured just by the change in how she posed for her photos. Cats are considered kittens until they are one year of age. Fortunately for Kierra, someone fell in love with her and took her home.

Cats are considered kittens until they are one year of age.

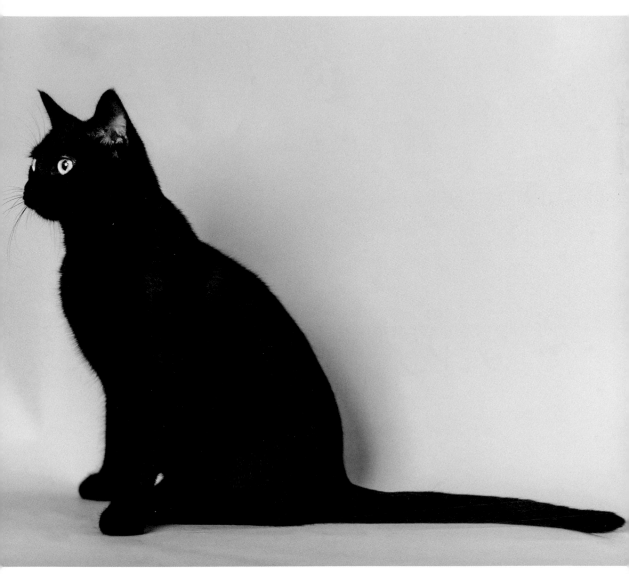

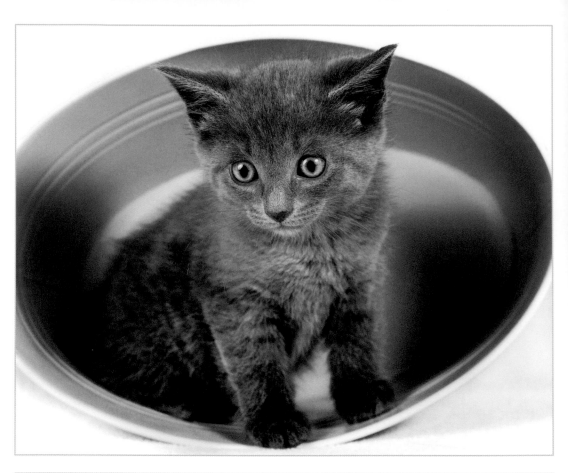

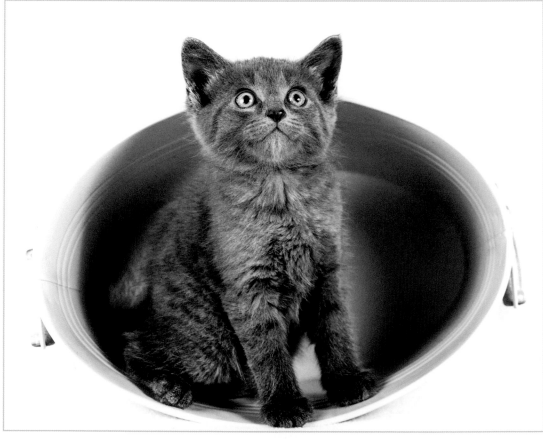

MAGNOLIA

(previous page) Magnolia, a typical playful kitten, was born into a rescue when her pregnant mom was saved from a rural high-kill shelter. This energetic kitten loved to play with toys and wrestle with her siblings. She was very quickly adopted.

OLIVE

(top and bottom) Olive, an independent kitten with a sweet and curious nature, was born into rescue along with his siblings, Magnolia, Chester, and Buckeye. When Olive was named, it was thought he was a girl; it is sometimes hard to determine the sex of a kitten when they are small. His gender wasn't discovered until he was already named, so Olive stuck. His mom was rescued from a high-kill shelter while pregnant, and Olive and his siblings were born in a foster home. Olive was the last of his litter to be adopted.

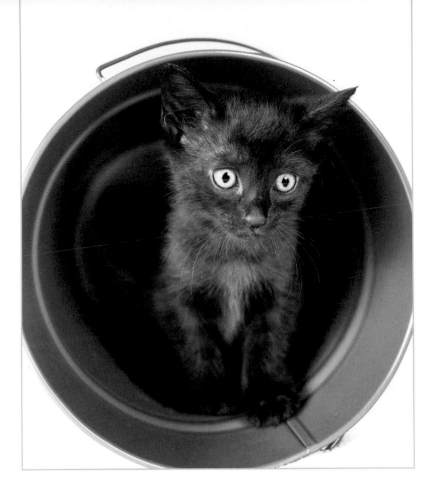

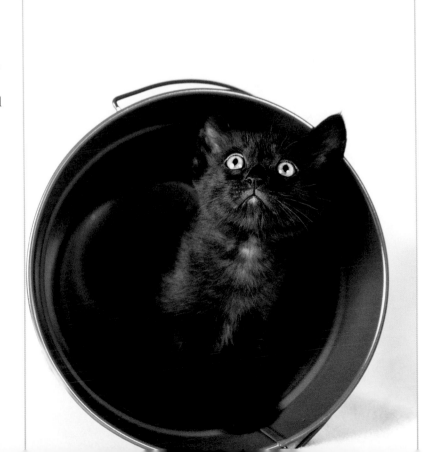

MAC

(*previous page*) Poor little tabby kitten Mac arrived at a small rescue at only three weeks of age after his mother was hit by a car. He was bottle-fed by the rescue and made his adoption debut when he was old enough to start interviewing for his forever family. Fortunately, when you're an adorable kitten like Mac, it doesn't take long to find a home.

QUIRKY

(*above*) Quirky and her littermates came to rescue from a rural high-kill shelter at around three months of age. Unfortunately, they were not in the best of health, and it was several months before Quirky could make her adoption debut, after she had been nursed back to health by her foster parent. Quirky, about six months of age in this picture, was adopted after several adoption events. As kittens age, they are harder to adopt out, as many people only want to adopt younger, smaller kittens.

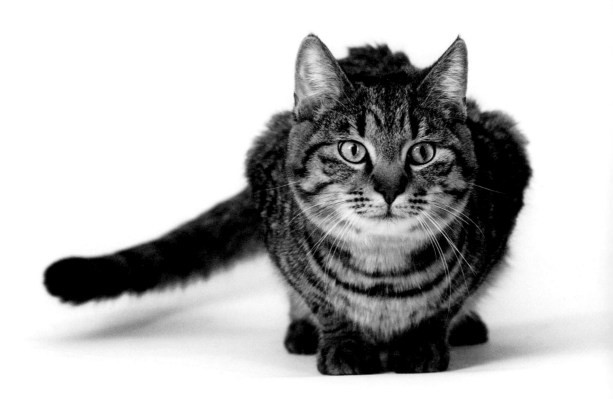

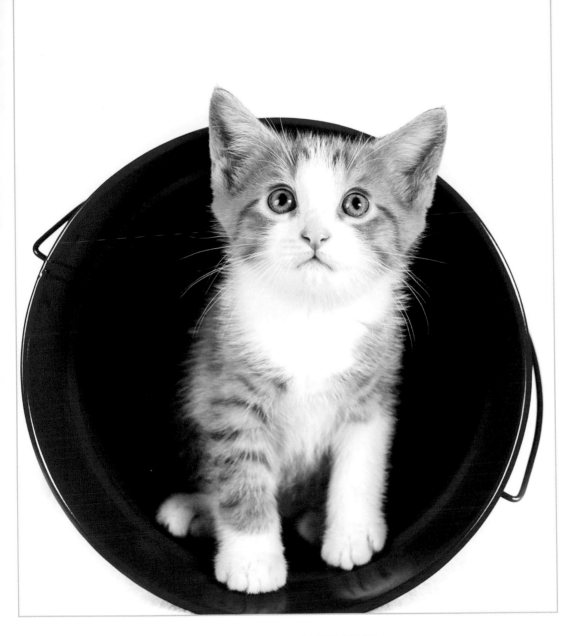

RAISIN

(previous page) At only nine months of age, Raisin is a big guy. He and his brother, Rye, were found by a good Samaritan who took them in and cared for them until they could get into a rescue. Raisin is a timid but playful guy. Raisin's brother, Rye, was adopted first, but it wasn't long before Raisin found a happy home of his own.

BUCKEYE

(above) Buckeye, an adorable orange-and-white, curious kitten was born into rescue when his pregnant mom was saved from a rural high-kill shelter. Buckeye—along with his mom, Willow, and siblings Chester, Magnolia, and Olive—lived in foster care until they were adopted. Fortunately, they didn't have long to wait.

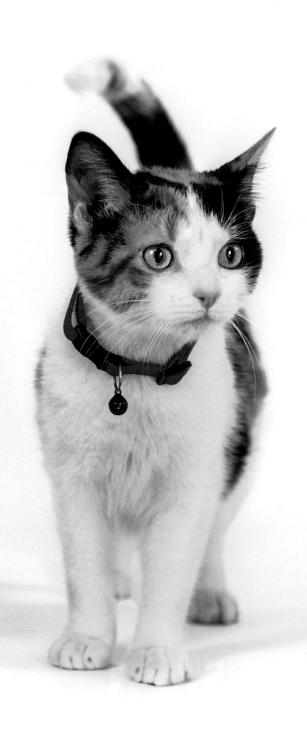

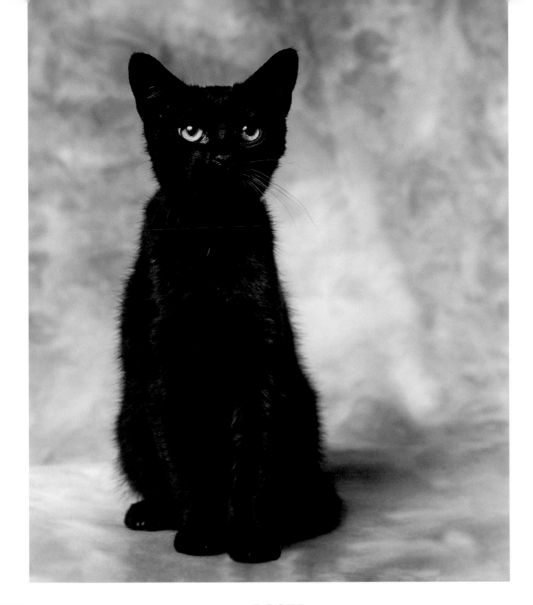

DAPHNE

(previous page) This petite calico girl is tiny at only seven months of age. She was adopted, but didn't get along with the other cats in a multi-cat home, so ended up back in a rescue before being adopted again.

ROGER

(above) Roger, a handsome seven-month-old black kitten, had a sweet and friendly personality. He was taken in by a rescue group who saved him from a high-kill shelter. Loving to play with toys and snack on treats made Roger very appealing, and he was quickly adopted, which is very lucky for a black cat, kitten or not, as black cats (and other black animals) are the most overlooked population when it comes to adoption.

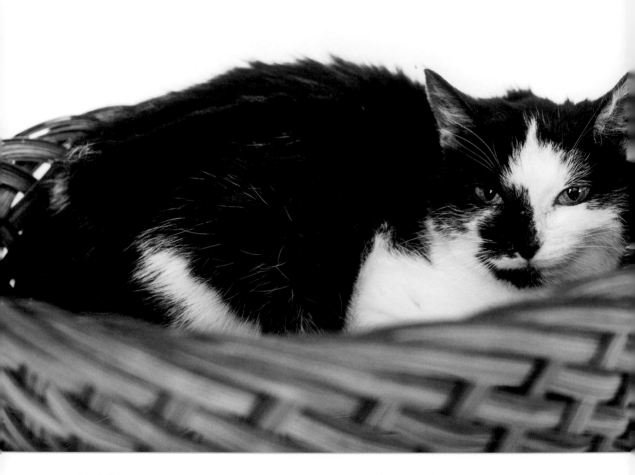

NOEL

(*above*) Noel and her sister, Coal, were found outdoors at around five months of age. Neither kitten is interested in human contact and both will likely remain feral in nature. Noel is not aggressive toward humans, just very untrusting of them. She is putting on some weight and learning to be less fearful of people while looking for a home where she might be comfortable.

NORBERT

(*following page*) Norbert, an adorable gray tabby kitten, ended up in a shelter (fortunately, a no-kill shelter) during kitten season, along with quite a few other kittens. This playful little guy melted hearts and soon won the affection of his forever family.

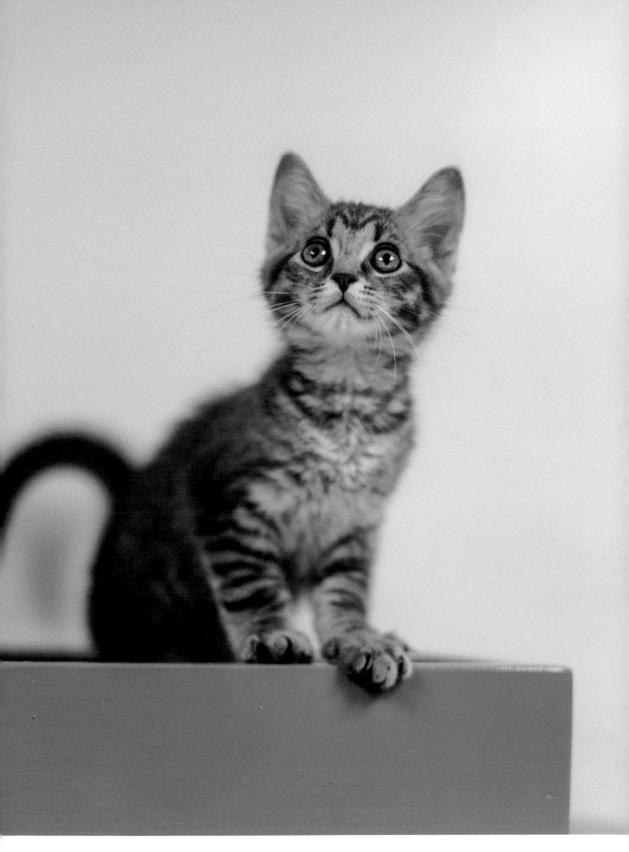

CHUCK

(below) Chuck, an adorable, yet tiny for his almost one year of age, Siamese kitten ended up at a shelter when his owner couldn't care for him. Fortunately for Chuck, it was a no-kill shelter, and this timid little guy was quickly snatched up and adopted.

POPSICLE

(following page) Popsicle, a fluffy medium-haired orange kitten, was brought to rescue from a rural high-kill shelter along with several other kittens. This cute, friendly guy was quickly adopted. Orange tabby cats are almost always male; approximately two out of ten orange cats are female.

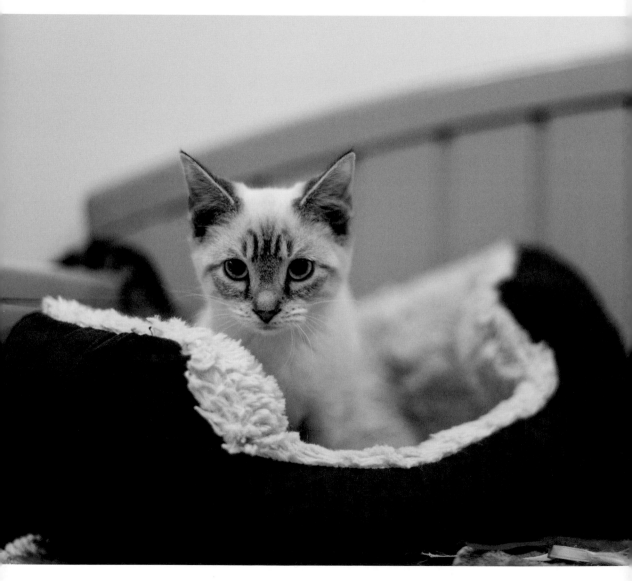

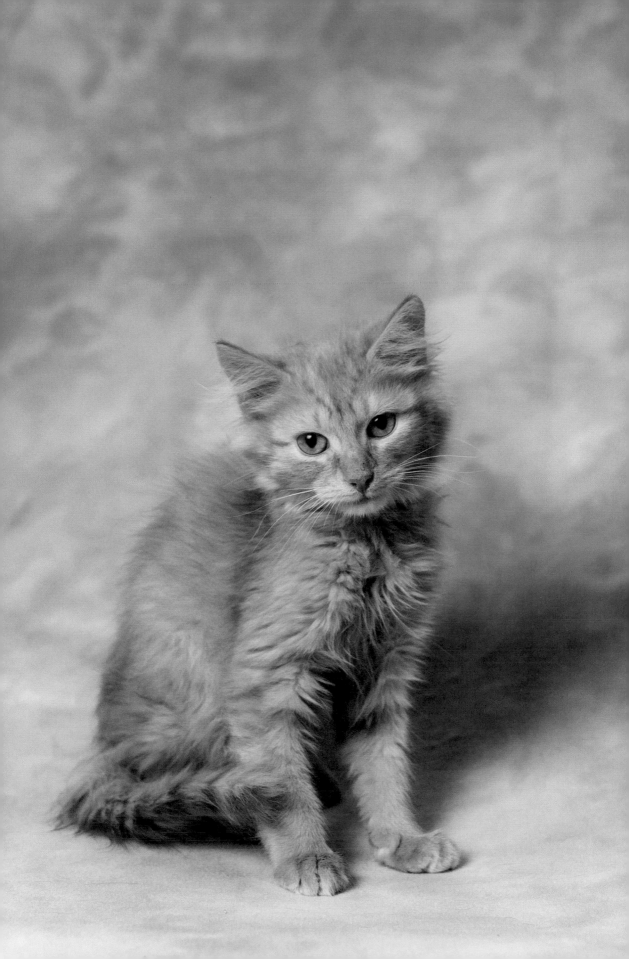

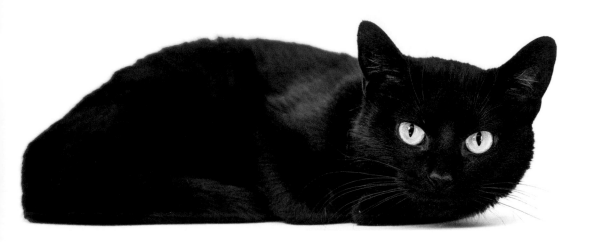

ESTHER

Esther and her sister, Little Girl, were found as strays and rescued by a good Samaritan. Esther is a talkative, friendly girl. She especially loves to give head-butts. Black cats typically find themselves awaiting adoption for a longer period of time than do other cats. However, they are no different than cats with other colorations and make fantastic pets.

Black cats typically find themselves awaiting adoption for a longer period of time than do other cats.

RAIN

Rain and her sister, Raya, ended up in a shelter during peak kitten season. Often, kittens are orphaned when something happens to the mother. Other young kittens wind up in rescue when they are spotted by a well-intentioned person who sees them alone and doesn't wait to see if the mother comes back to them. This little dilute calico didn't last long at her no-kill shelter, as kittens are usually adopted before adults.

Rain and her sister Raya ended up in a shelter during peak kitten season.

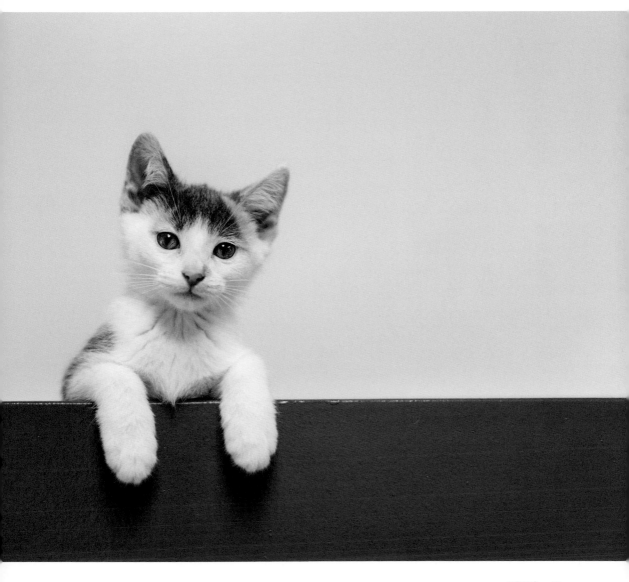

RAYA

(below) Raya and her sister, Rain, ended up at a no-kill shelter at around two months of age. At the shelter they were placed in one of the kitten rooms, which provide lots of interactivity and socialization, both important for kitten development. Raya didn't spend too long at the shelter as she was quickly adopted.

REEBOK

(following page) Reebok, a three month old tuxedo kitten, ended up in rescue as a single kitten. This little girl came from a rural shelter and she could either have been found solo or had her littermates not survive shelter life. Once in rescue she was taken care of by a foster until she was adopted.

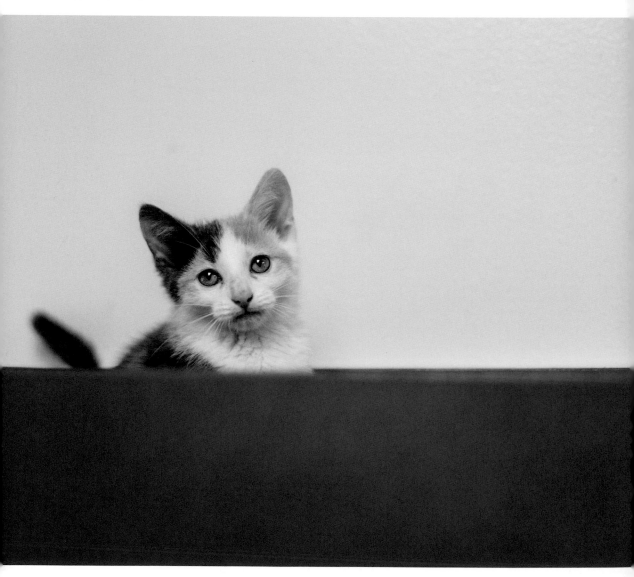

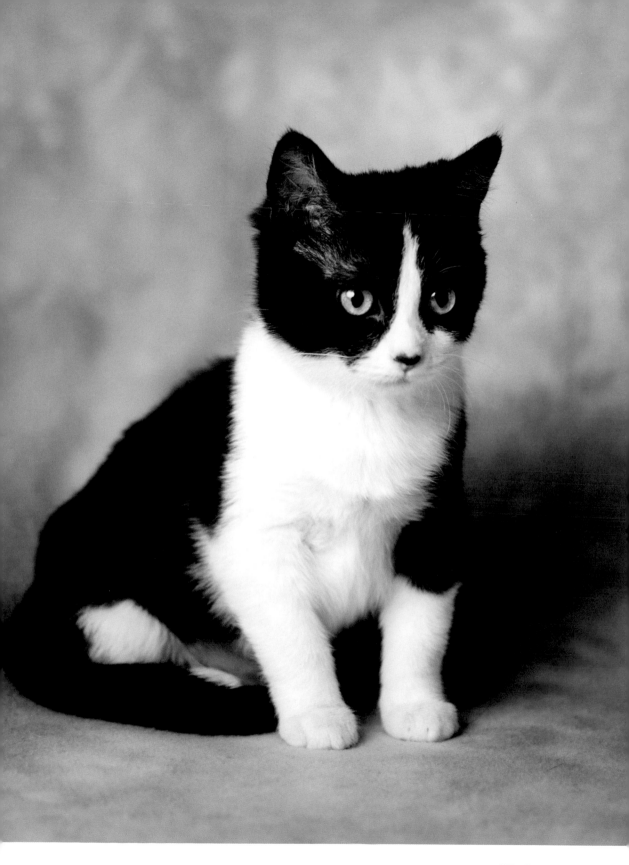

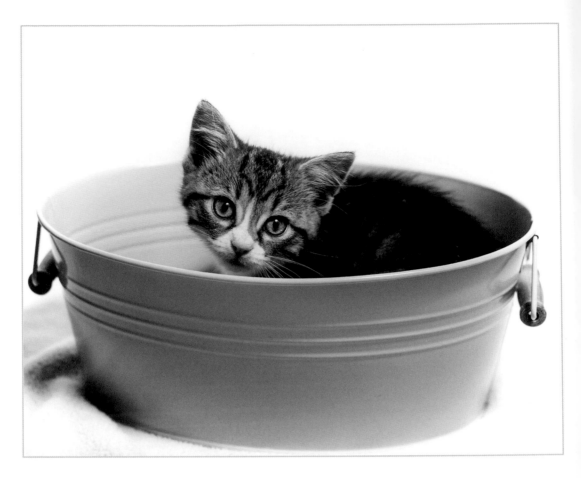

MARIE

(above) Marie and her siblings were born in rescue. Their pregnant mom came from a rural high-kill shelter, where many kittens never get the opportunity to be born. Unfortunately, cats are the most euthanized animal in shelters, and it is quite common for pregnant mothers to be put down.

PABLO

(following page) Pablo, a delightful orange tabby, and his brother, Pong, enjoyed time in their no-kill shelter's kitten room until they were both adopted at a little over three months of age. Cat litters can range in size from one to ten, so it is unknown if there were more littermates for Pablo and Pong. It is not unusual for just one or two kittens to end up in a shelter or rescue at a young age.

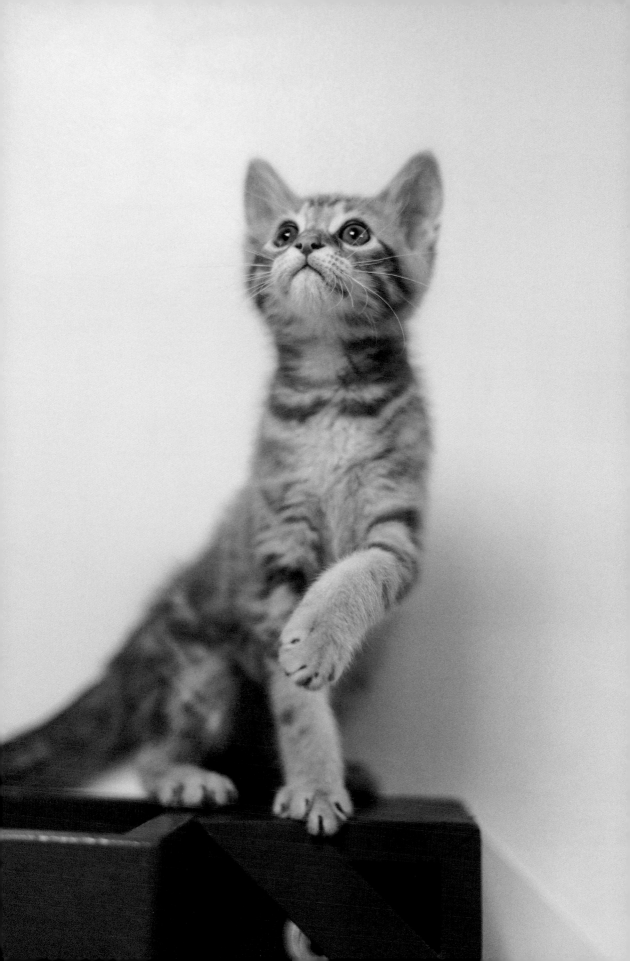

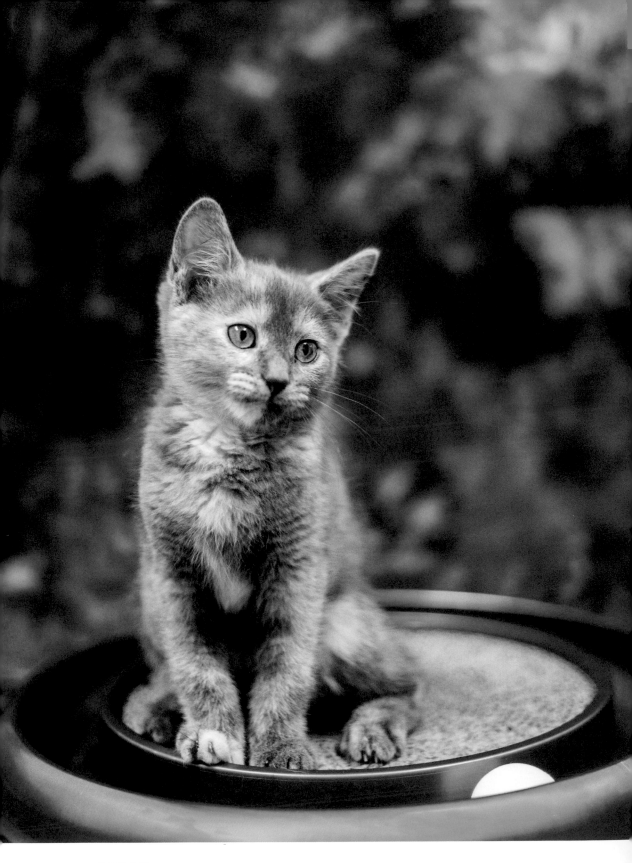

PING

(previous page and below) Ping, a three-month-old dilute tortie kitten, ended up at a no-kill shelter during peak kitten season. This playful girl was quickly adopted. Dilute torties do not have the typical black-and-orange coloration of a tortoiseshell cat; they have softer orange and cream colors, with the predominant color being gray. It is extremely rare for a male cat to be a tortoiseshell. When a tortie is a male, he is likely sterile.

It is extremely rare for a male cat to be a tortoiseshell. When a tortie is a male, he is likely sterile.

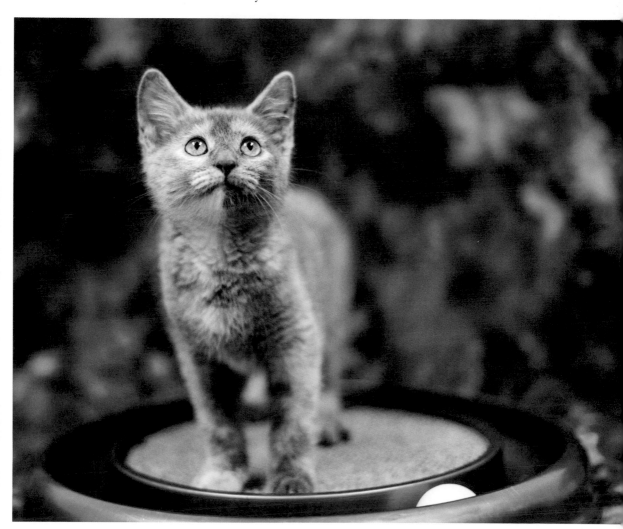

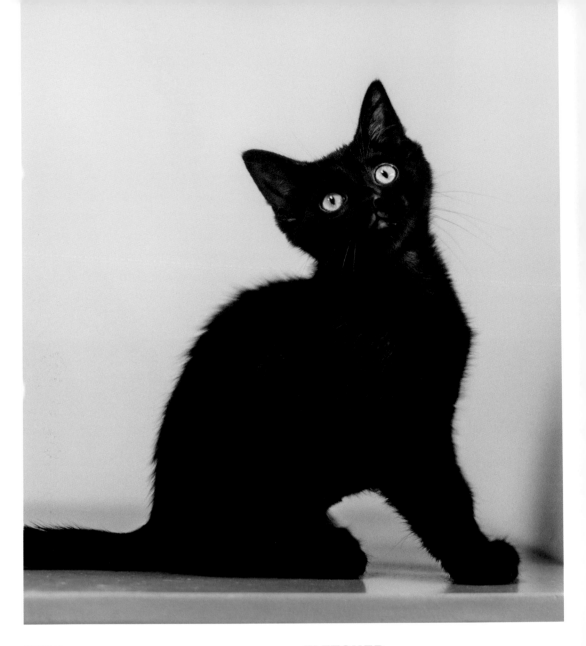

LYRA

(above) Lyra arrived at a no-kill shelter with her littermates. A single litter of kittens can all look completely different or they can have similar coloring or marking depending on their antecedents. In Lyra's case, this all-black kitten had a gray-and-white sister, a solid-gray brother, and a black-and-white brother.

FLETCHER

(following page) Fletcher, a two-month-old tabby, was full of personality. He was already pending adoption when he was photographed. While kittens are typically adopted before adult cats, those who have unique coloring or playful personalities are often adopted ahead of the other kittens.

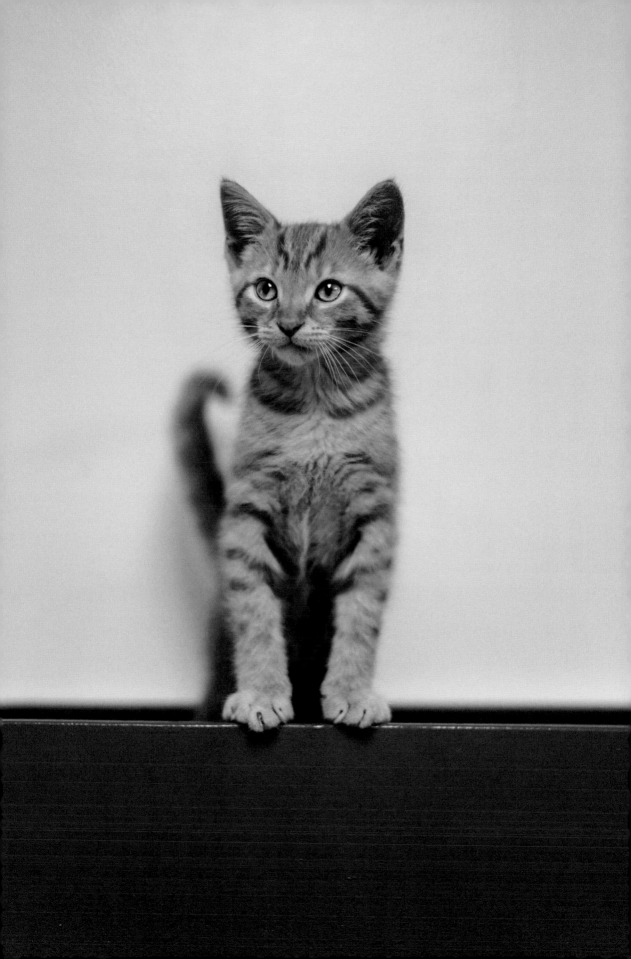

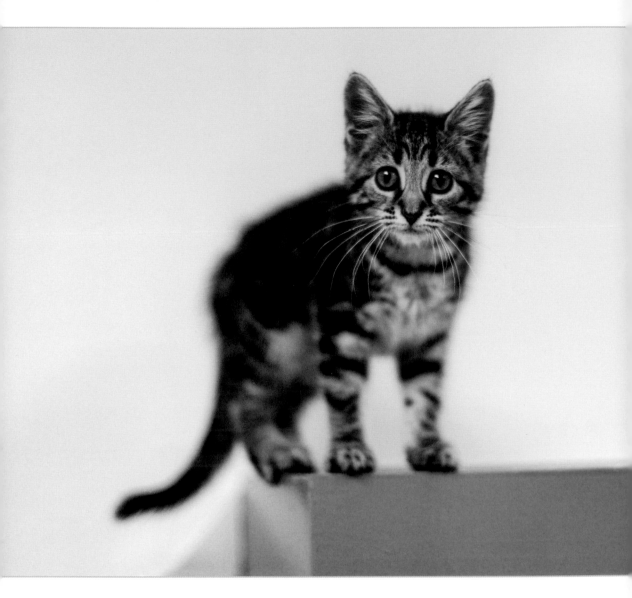

Her playful and friendly personality was able to shine in the shelter's kitten room, and she was quickly adopted into her forever home.

PRIMA

(*previous page and below*) Prima, an adorable three-month-old tabby kitten, ended up at a no-kill shelter. Her playful and friendly personality was able to shine in the shelter's kitten room, and she was quickly adopted into her forever home.

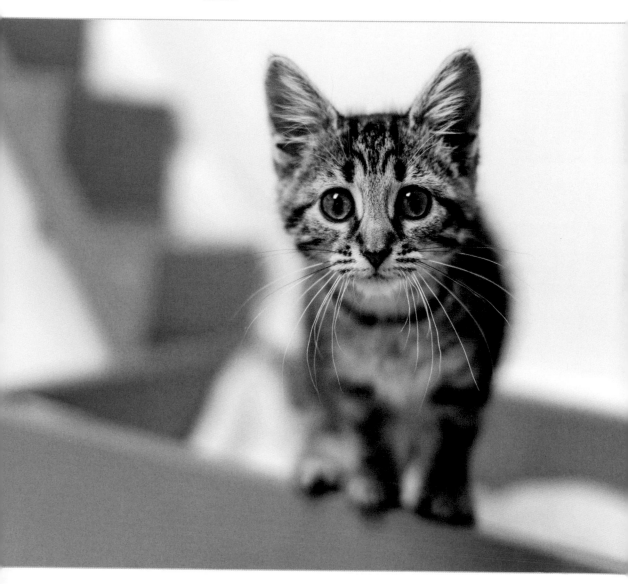

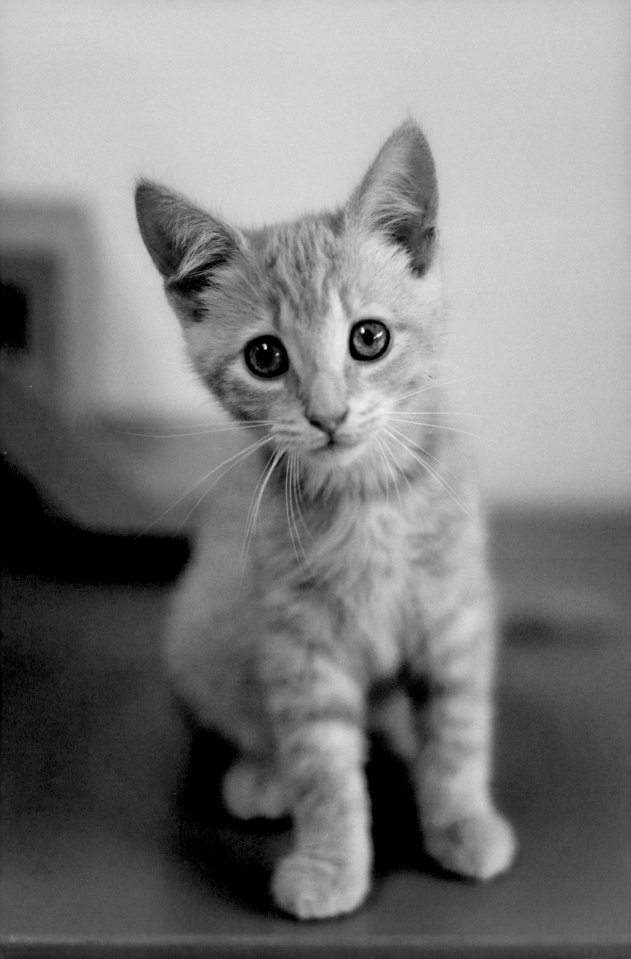

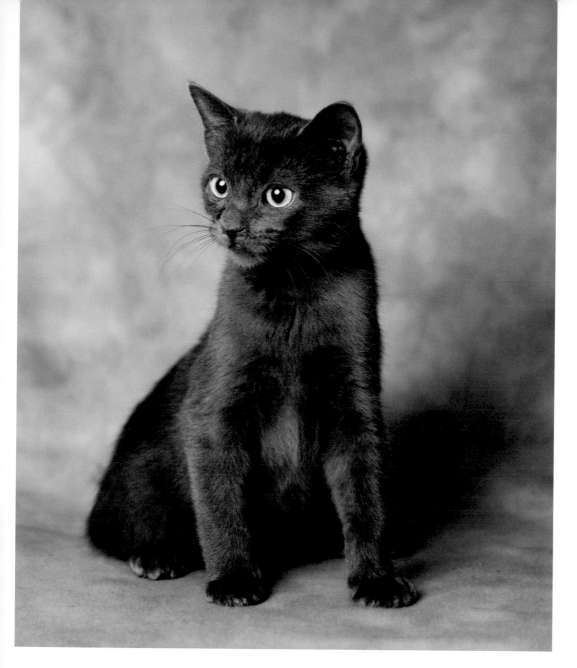

NEPTUNE

(previous page) This curious buff-colored kitten was just two months old when he and his sibling, Norbert, ended up at a no-kill shelter. They were both adopted very quickly, as the shelter does a great job of making sure kittens have the opportunity to let their playful personalities shine.

MAKO

(above) Four-month-old Mako, a handsome gray kitten, was taken in by a rescue after he was saved from a rural high-kill shelter. This handsome little guy spent extra time at his foster home while he battled some health issues before being adopted.

2 ADULT CATS

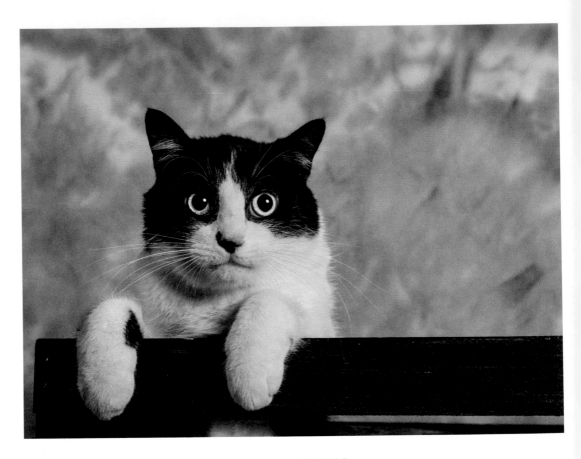

BATMAN

(*above*) Batman is an approximately one-year-old male cat who was hiding out at a local business with another cat. The pair were very wary of humans, but Batman was able to be trapped and taken in by a rescue and now lives in a foster home. Batman is learning to trust people.

GARY

(*following page*) Gary was found as a stray before being taken into a rescue. He was hanging out at an adoption center in a small local pet supply shop, where he learned to be an indispensable part of the store. The store owners decided that Gary had already found his home. Today, Gary lives a life of luxury as the top boss cat at the store, where he is appropriately fawned over by the staff and clientele.

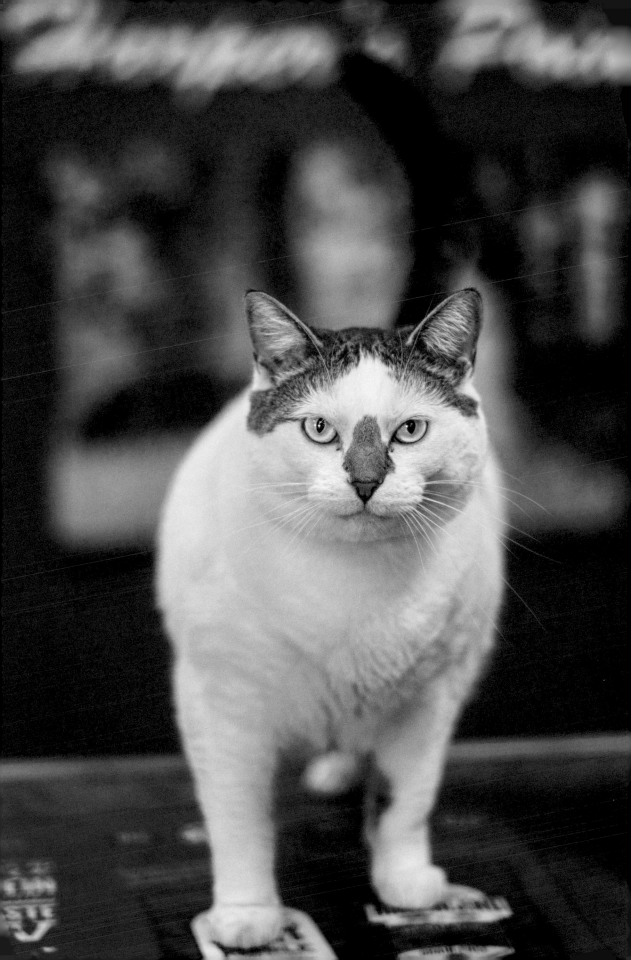

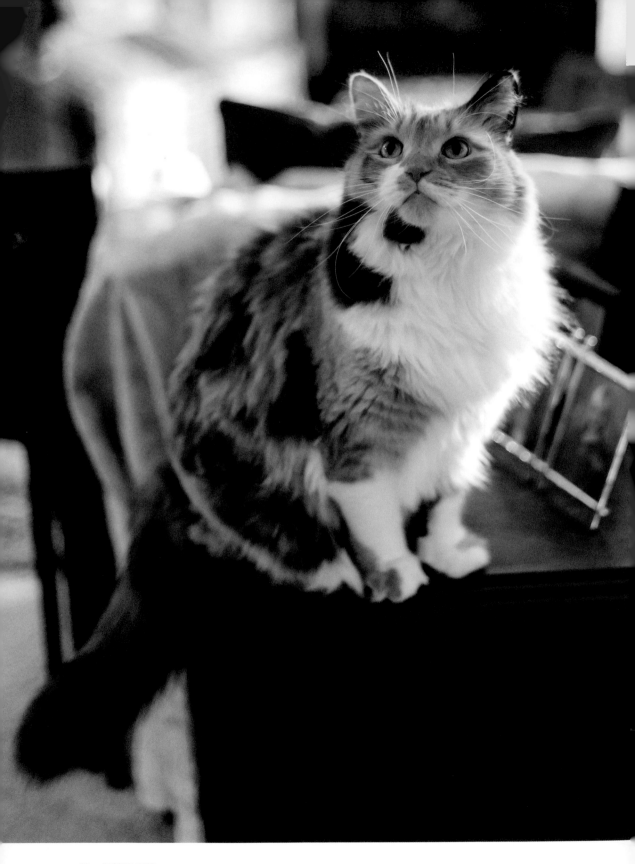

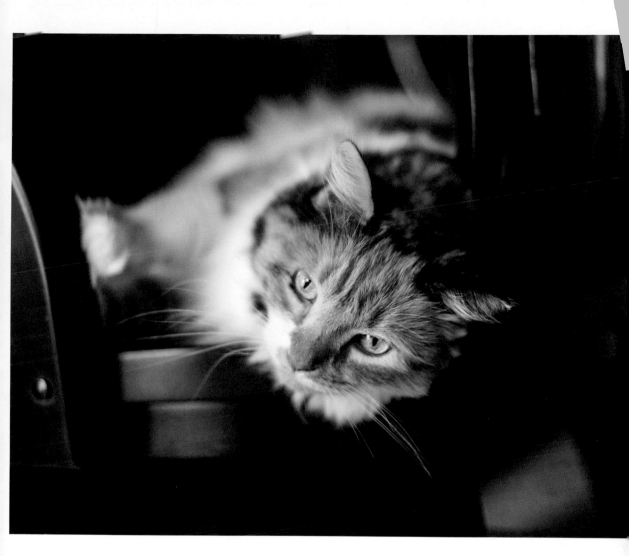

MIRANDA

(previous page and above) Eight-year-old Miranda and her sister, Sophie, were both rescued as kittens by an animal-loving judge who found them abandoned at a gas station in Lawrenceburg, Indiana. The area was a well-known dumping ground for unwanted animals. Miranda loves to be the center of attention and, in fact, demands it. She is a gorgeous long-haired calico, and she knows it!

Miranda loves to be the center of attention and, in fact, demands it.

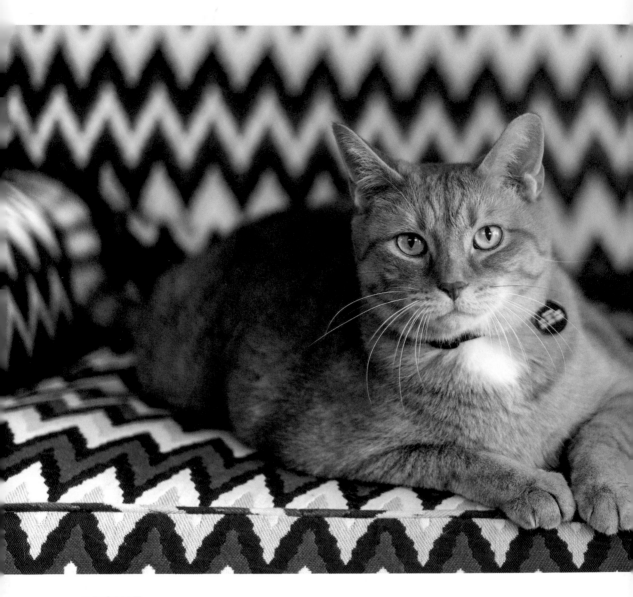

ARCHIE

Archie, approximately eight years old, is a big, handsome
orange tabby cat. He was adopted from the Hamilton
County SPCA in Cincinnati at a mobile adoption event.
He was the only cat at the event and fell asleep in the arms
of a volunteer, who ended up adopting him. He is the only
cat she ever paid an adoption fee for, as she rescued all her
other cats off the streets.

Archie, approximately eight
years old, is a big, handsome
orange tabby cat.

OSCAR

Oscar, a handsome five-year-old tuxedo cat, was adopted from a rescue group that took him in after his former family moved away, leaving him to fend for himself. A volunteer with the rescue saw him every day as she went to work and decided to help this friendly kitty find his true forever home. Sadly, Oscar passed away just two years after he was adopted following a battle with an aggressive cancer. Through it all, Oscar never lost his friendly and loving nature.

A volunteer with the rescue saw him every day as she went to work and decided to help . . .

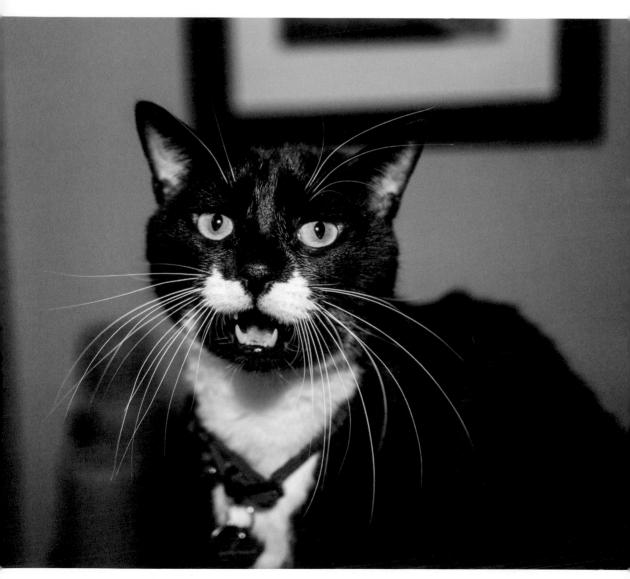

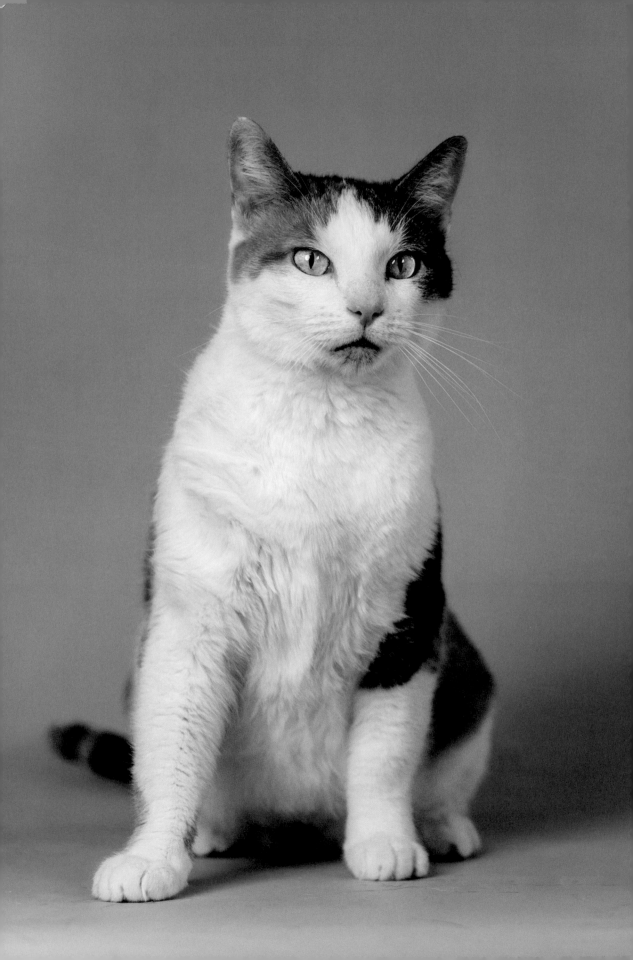

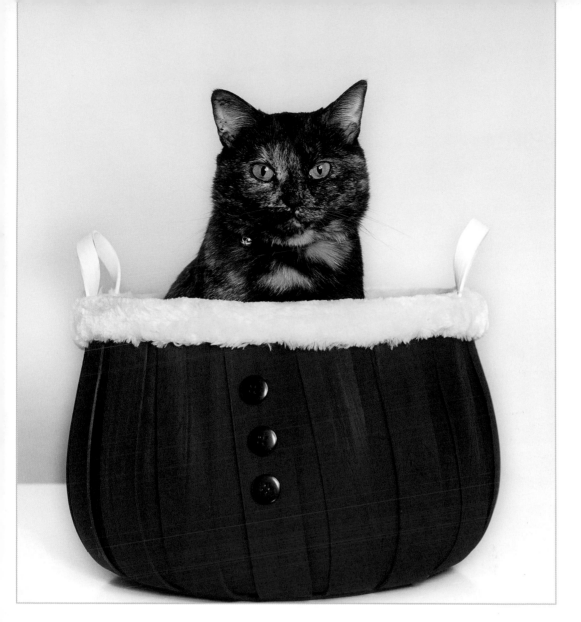

JUNIE B

(*previous page*) June Bug, or Junie B, is a sweet and sassy calico girl. She is approximately two years old. She ended up in a small rescue in the Cincinnati area and, after more than six months in rescue, finally got a home of her own.

DIANA

Diana, a three-year-old tortoiseshell cat, was brought to a rescue in Cincinnati from a rural Eastern Tennessee shelter. She was mom to the Royals: William, Harry, George, Kate, and Charlotte. Diana was adopted by her foster family (me) and is the only cat in a house full of dogs. She fits right in, though, and loves to play with her chihuahua brother, Paco.

CEDELLA

Cedella is a super talkative kitty and single mom to four boys. She and her little family ended up in a small rescue in Cincinnati so they could start the task of interviewing for their forever homes. Cedella, a regal lady, enjoys drinking from the kitchen sink and begging for food. It took a while, but eventually she found a home of her own.

Cedella is a super talkative kitty and single mom to four boys.

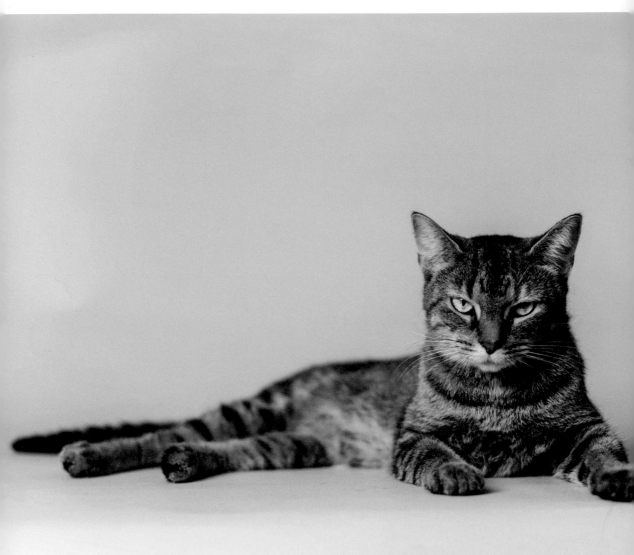

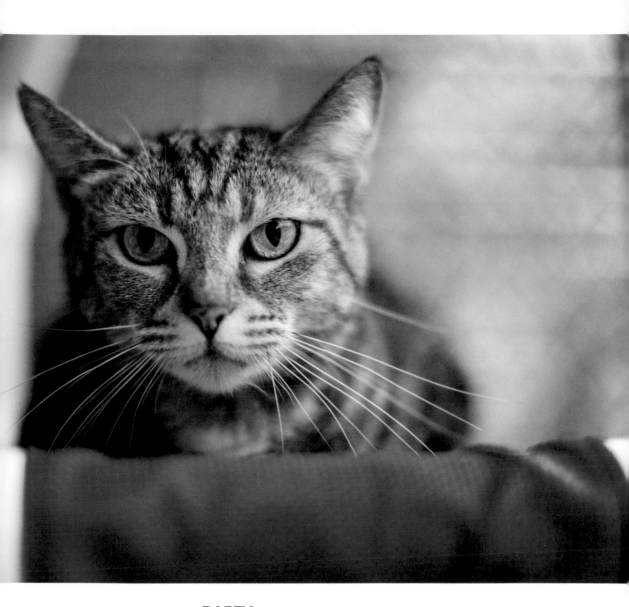

At over seven years old, Daffy is a quiet kitty who enjoys attention and being petted.

DAFFY

At over seven years old, Daffy is a quiet kitty who enjoys attention and being petted. She was found as a stray and taken to a no-kill shelter in the Cincinnati, Ohio, area. Housed in a room with enclosed outdoor access, she likes to explore and see the outside world. Daffy is still interviewing for her forever home.

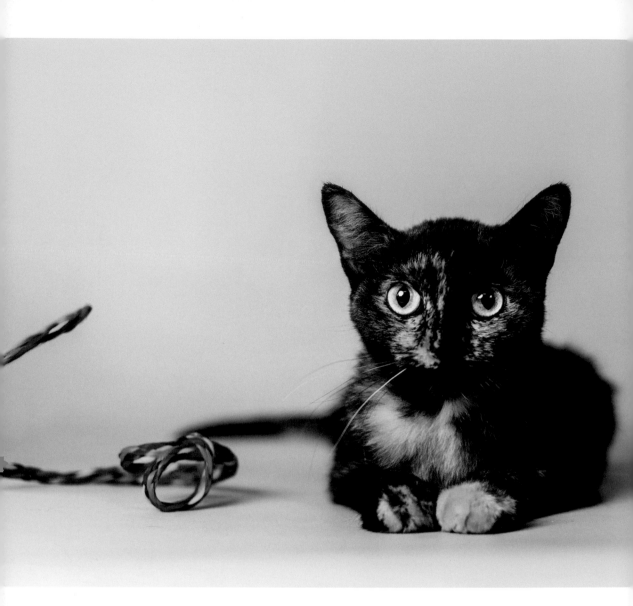

LADY

(above) Lady, a beautiful tortoiseshell kitty, was found in a dumpster behind a pet store, crying for help. She was producing milk, but a thorough search of the area didn't turn up any kittens. She is a very sweet and loving kitty who just wants a happy, rags-to-riches ending to her story.

RAZZIE

(following page) Razzie, a six-year-old gray-and-white domestic short-hair, ended up in a Cincinnati area no-kill shelter in 2016, when her owner could no longer take care of her. She is an independent kitty who wants attention on her terms. She spends hours birdwatching and will occasionally play with a cat toy. She is looking for a home where her diva personality can shine.

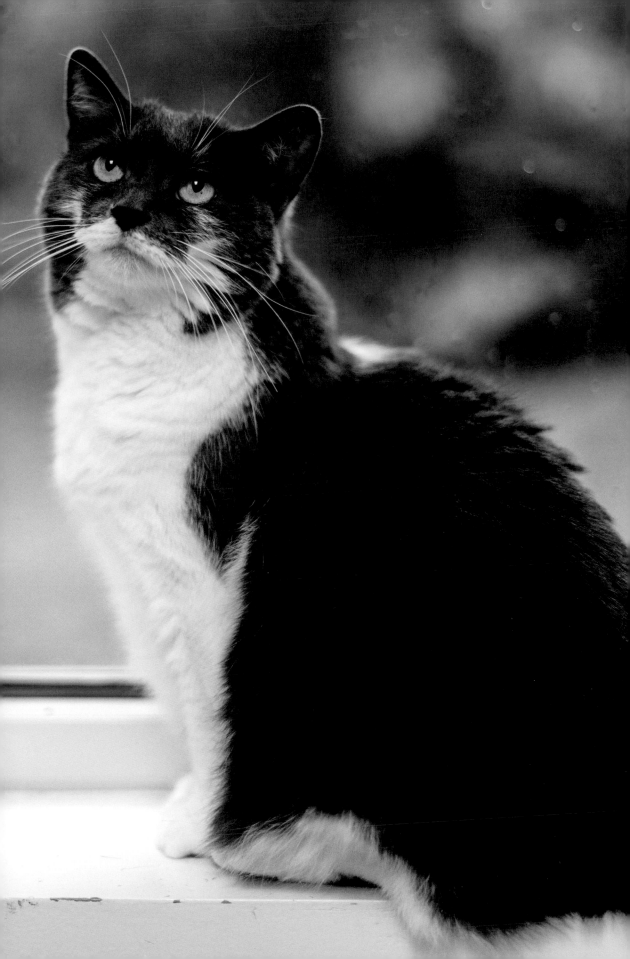

MO

(below and following page) Two-year-old Mo is a super curious and friendly tuxedo cat. He was found as a stray kitten by the clinic manager of Pets in Need (PIN) of Greater Cincinnati in the north-side area of the city. He was adopted in a moment of weakness (hence the name, Mo) by the executive director of PIN and joined her multiple-cat family.

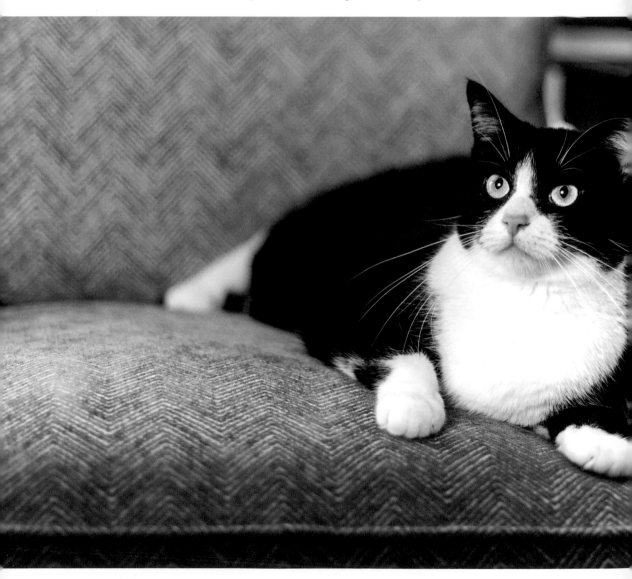

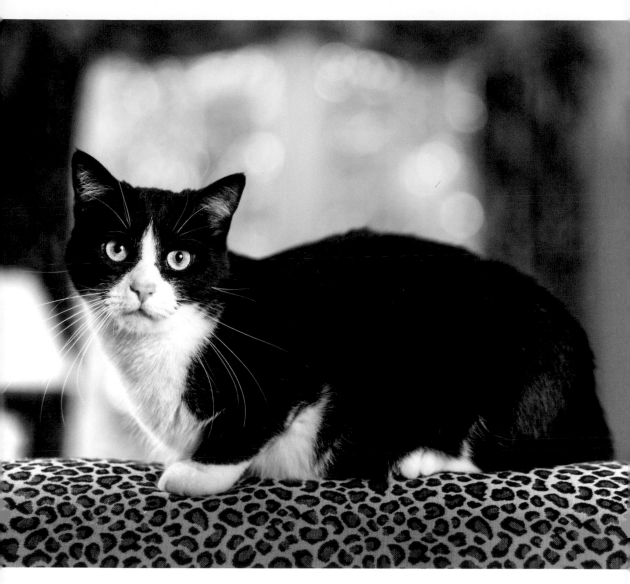

Two-year-old Mo is a super curious and friendly tuxedo cat.

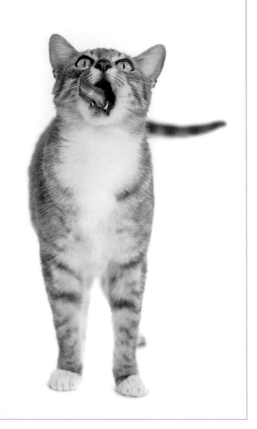

GRACIE

(this page and following page) Gracie is a gorgeous silver tabby cat with a sweet personality. She was found as a stray before being brought to a rescue. She is a chatty and friendly girl who is also highly food-motivated. This delightful girl was lucky to find her forever home.

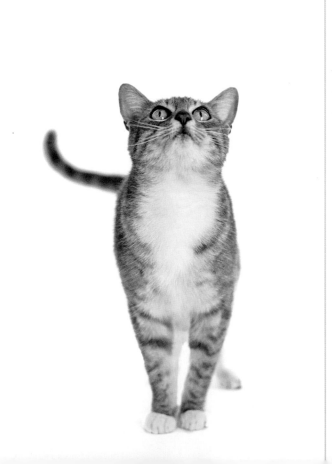

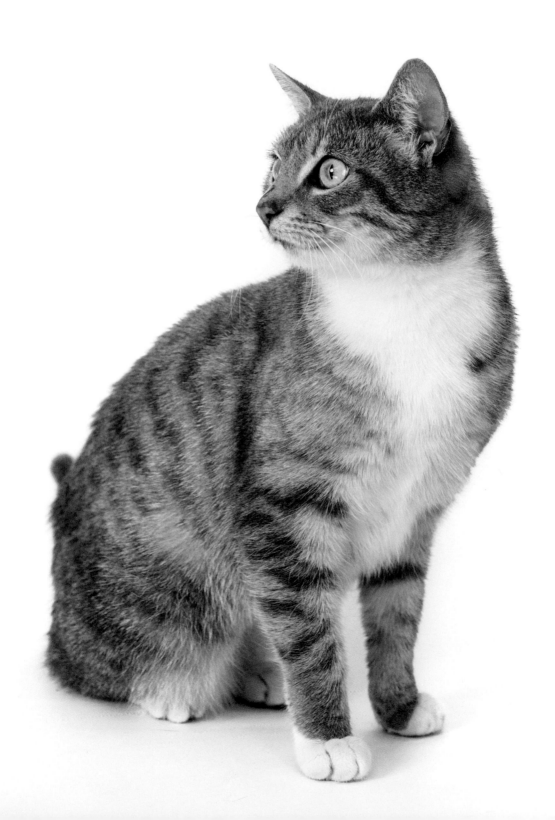

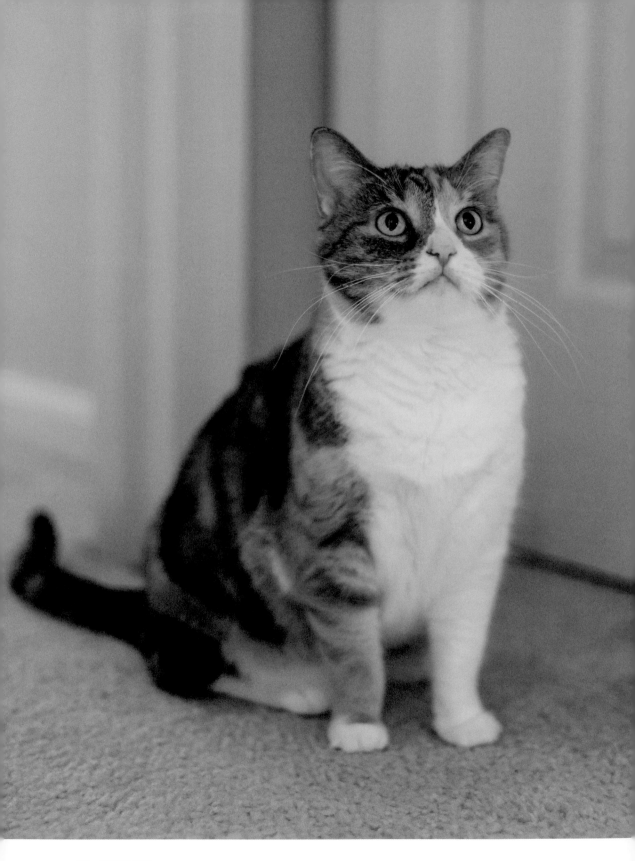

SOPHIE

(previous page and below) When Sophie was a kitten, she (along with her sister, Miranda, another sibling, and mom) was dumped as at a gas station in Lawrenceburg, Indiana. Fortunately, they were all rescued, and Sophie and Miranda were adopted together. While her long-haired sister Miranda is the belle of the ball, Sophie is mainly content to play second fiddle. Don't let that fool you into thinking Sophie doesn't like plenty of attention herself, though! Sophie and Miranda live with their senior kitty brother, Max, also featured in this book.

. . . Sophie is mainly content to play second fiddle. Don't let that fool you into thinking Sophie doesn't like plenty of attention herself, though!

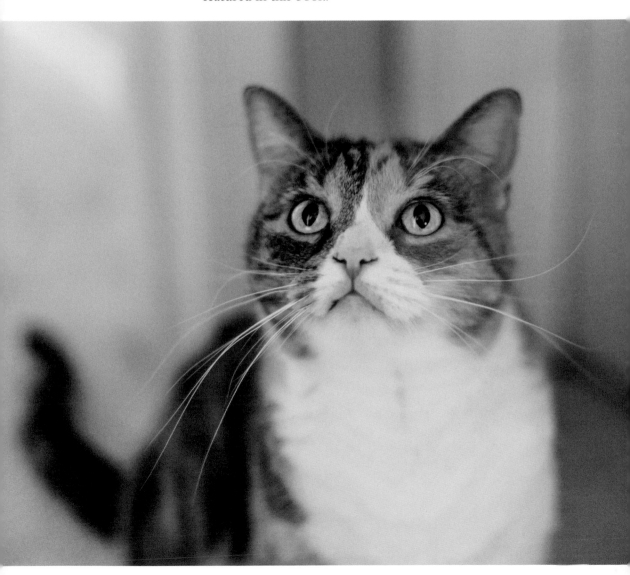

HOLLY

(below) Holly is a sweet and friendly black cat with a tiny bit of white on her chest. She loves to explore and will jump in your lap for cuddles and rubs. She is approximately three years of age and loves to chat.

FLY

(following page) This nine-year-old handsome tuxedo kitty just loves people. He's rather sweet and friendly, so it's surprising that this boy hasn't found a home of his own yet. Luckily, Fly was sent to a no-kill shelter after he ended up in a traditional (kill) shelter as a stray. Fly is friendly with everyone, including other cats. He loves to play ball and doesn't have a mean bone in his body. Hopefully, someone will look past the fact that Fly isn't a kitten and will adopt this great cat soon.

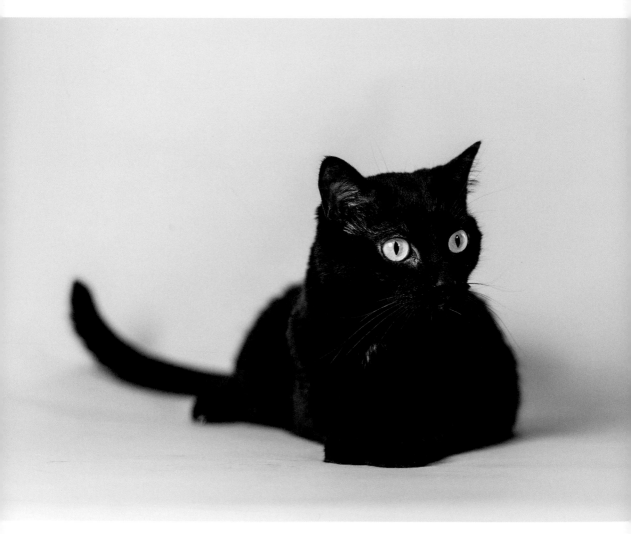

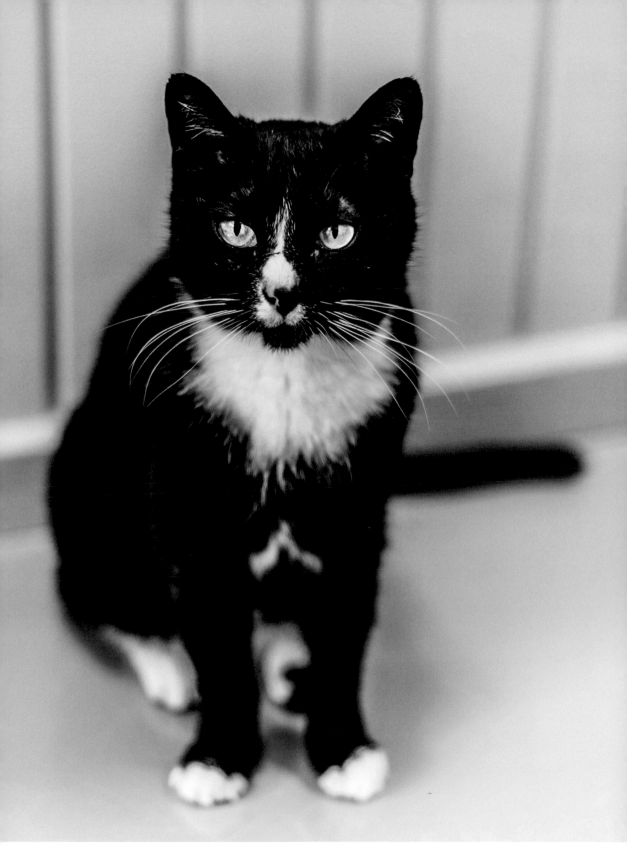

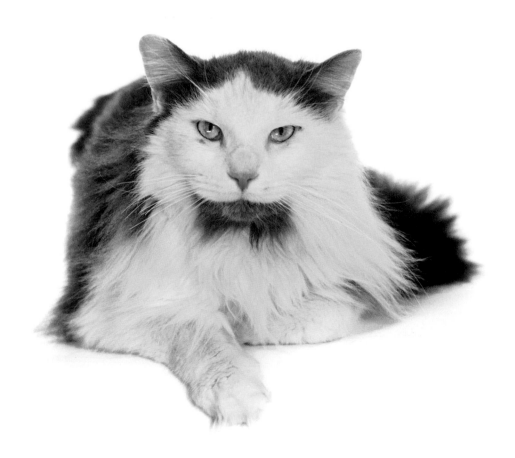

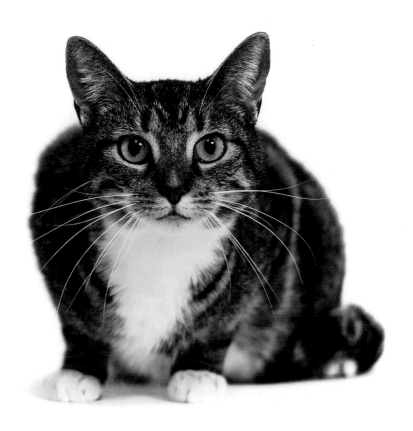

FUZZBART

(previous page) Fuzzbart is a handsome long-haired kitty around two years of age. He was found as a stray when he showed up at a heated outdoor shed on a rural Cincinnati area property. Fuzzbart is very friendly with humans, but is somewhat timid around other cats. He is, however, a playful guy.

CHESTER

(above) Don't let the name fool you: Chester is a sweet tabby girl. She's around four years old and arrived in a small rescue with her littermate, Dakota, and two other housemates after her owner passed away. She is an affectionate and loving kitty.

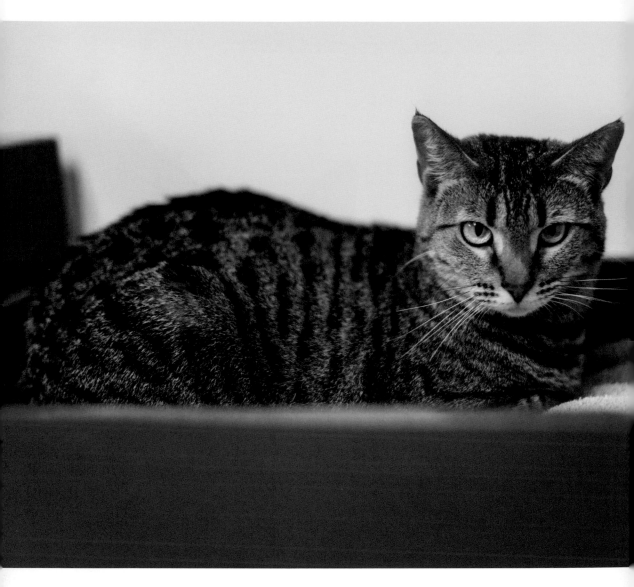

ROBBINN

(above and following page) Robbinn is a petite and quiet tabby girl around three years of age. She is a little shy, but if you approach her with a soft voice and give her a gentle pet, you'll find that she comes out of her shell and starts to purr. Robbinn absolutely thrives on attention and likes to talk to people. This sweet girl currently resides in a no-kill shelter in the Cincinnati, Ohio, area, where she has lived for over two years.

This sweet girl currently resides in a no-kill shelter in the Cincinnati, Ohio, area, where she has lived for two years.

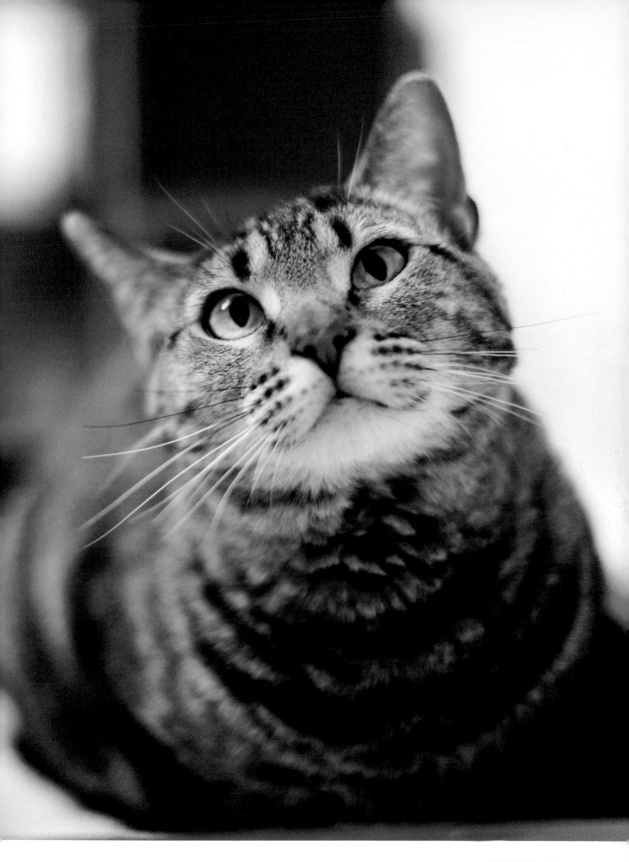

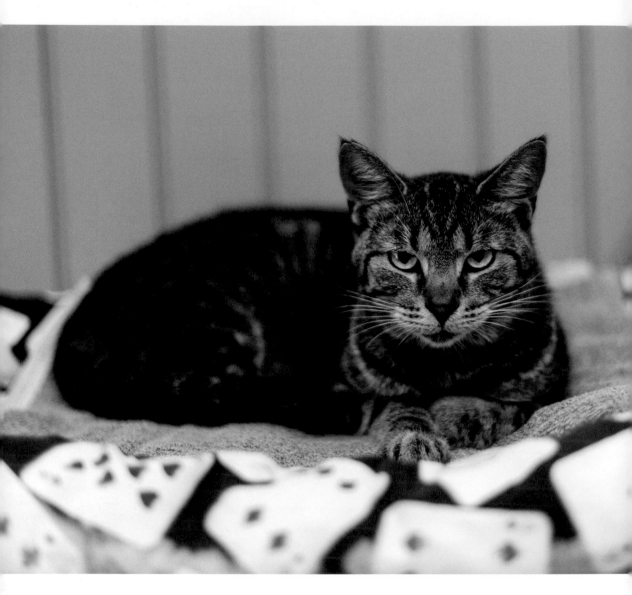

FIREBALL

Fireball is a shy cat around two years of age. He currently lives at a no-kill shelter in the Cincinnati area where he continues his search for a forever home. This shy boy loves attention, but you have to come to him and win his trust. He does like to play with dangling toys and would love a home where his quiet personality can shine.

This shy boy loves attention, but you have to come to him and win his trust.

AUTUMN

Autumn doesn't know why she ended up at a shelter, as she used to have a home with kids and other cats. Unfortunately, one of her household members became allergic to cats, and Autumn ended up without a home. Autumn is around six years of age and has been living at a Cincinnati area no-kill shelter for about a year. She is a little shy, but responds to gentle touches. She has a sweet personality and is looking for a home where she can be safe and loved.

She has a sweet personality and is looking for a home where she can be safe and loved.

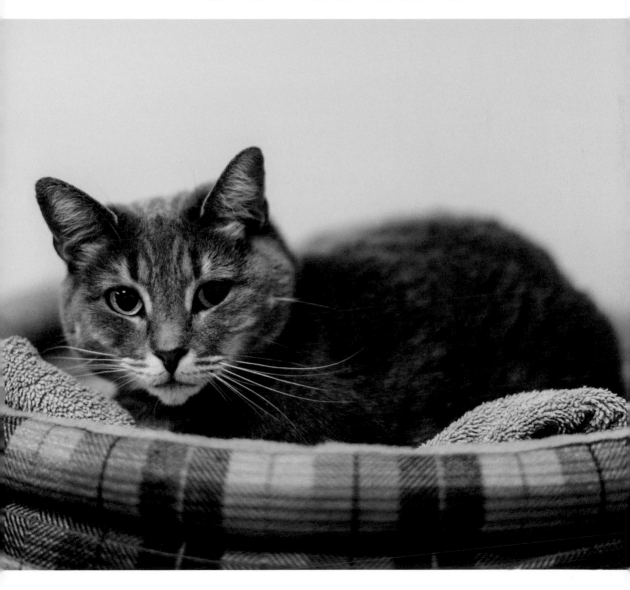

ARBEE

Arbee is nearing two years of age. She was found in a grave-yard before she ended up at a no-kill shelter. She longs to have a family to give her the love and attention she craves. Arbee doesn't mind other cats, but has to be the one to get attention first.

Arbee doesn't mind other cats, but has to be the one to get attention first.

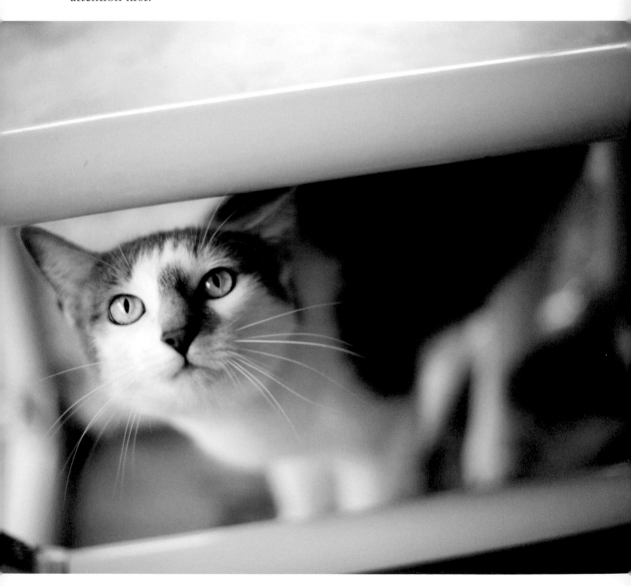

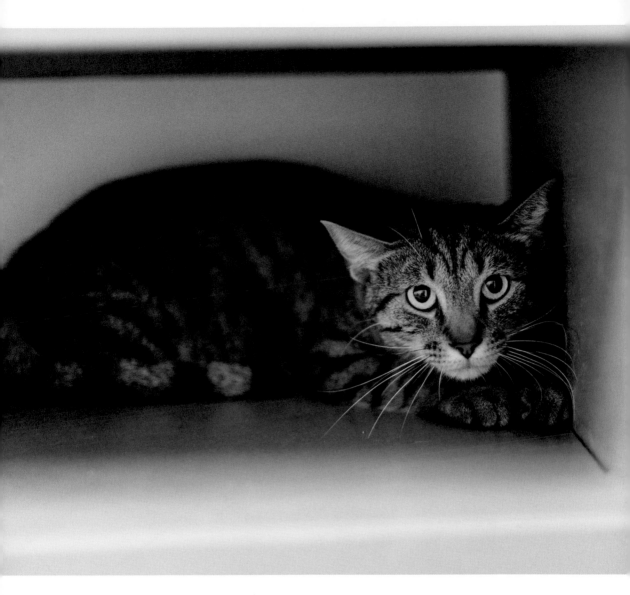

CLARKSON

Clarkson is slow to build trust
and therefore needs someone
who can offer a lot of love . . .

Clarkson is a male tabby cat around a year-and-a-half old.
He was found as a stray and was still adjusting to shelter life
when he was photographed. He is looking for a quiet forev-
er home where he knows he will be loved. Clarkson is slow
to build trust and therefore needs someone who can offer a
lot of love and patience.

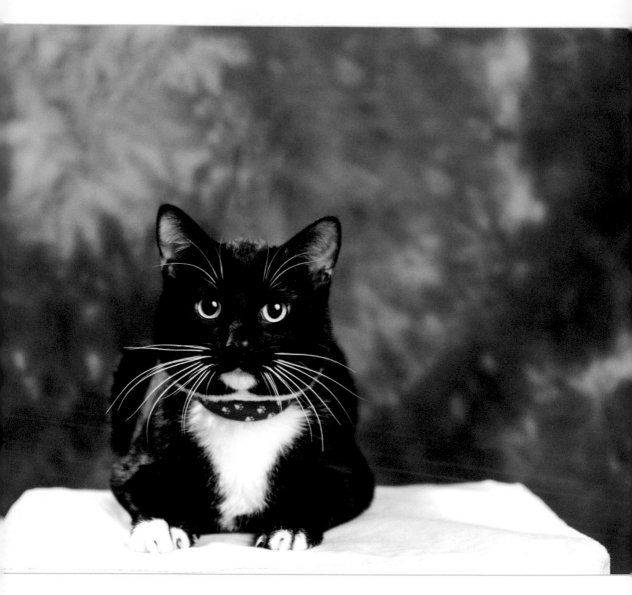

ZACK

Zack, a handsome and friendly tuxedo cat around two years old, was very lucky to be rescued after someone left him locked in a cage in a parking lot during a frigid winter spell. He was taken in by a rescue and lived in a foster home until he was adopted. Zack loves sitting and watching the birds at the feeder.

Zack loves sitting and watching the birds at the feeder.

TYGGER

Tygger is a handsome orange
kitty who loves playing with all
kinds of toys.

Tygger is a handsome orange kitty who loves playing with
all kinds of toys. He is less than two years old and was found
as a stray before being brought to a no-kill shelter. Tygger
loves to approach people for pets and playtime. This friendly
guy was quickly adopted into a loving home.

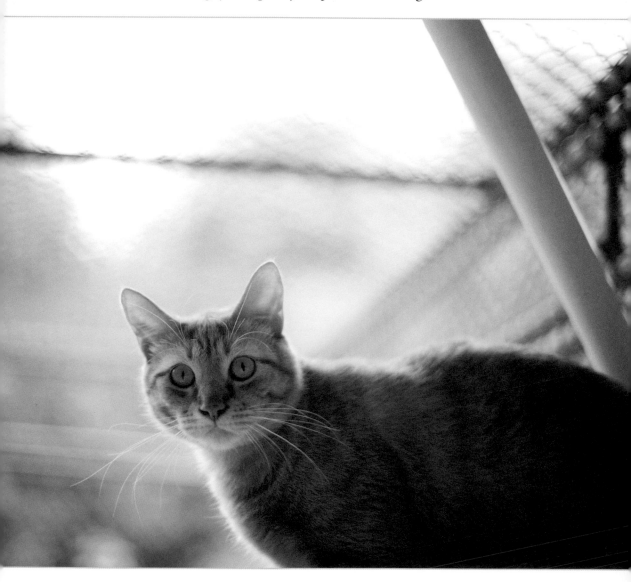

GAM

(below) This two-year-old little calico girl is a survivor. She was found in a field unable to move her back legs because she had been shot in the back with a BB gun. A good Samaritan found her and brought her to the local no-kill shelter where she received medical attention. The surgery helped, and she regained use of her back legs, but occasionally walks with a limp. Despite her rough life, she still loves people and loves to be petted. The friendly and sweet Gam was fortunate to find her forever home.

EMMY LOU

(following page) This curious torbie cat is around two-and-a-half years old and super sweet and friendly. Torbie cats are predominantly red in color (instead of the tortie black), with tabby stripes added into the mix. "Torbie" is short for "tortoiseshell–tabby." Emmy Lou found herself at a no-kill shelter before she was adopted into a loving home.

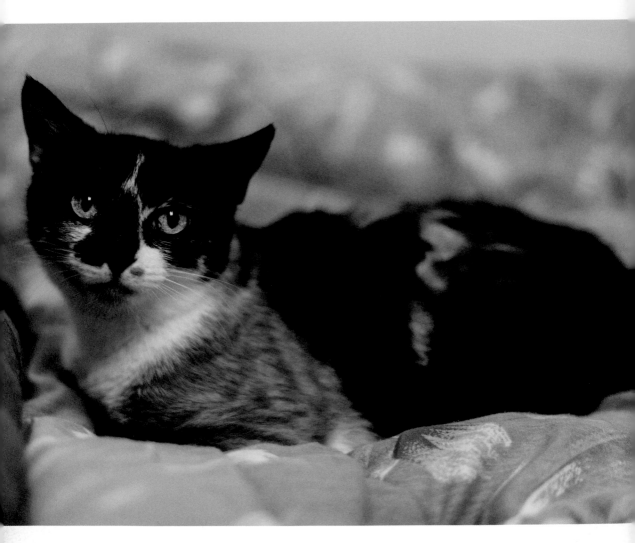

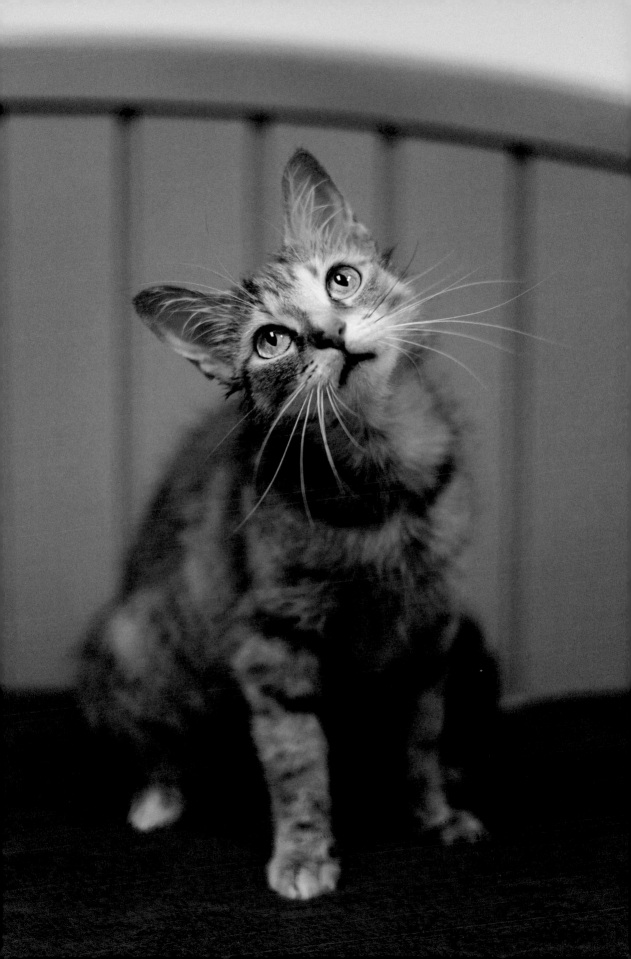

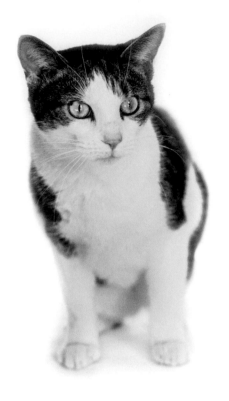

FRISKY

(*above*) Frisky is a tabby-and-white cat who loves nothing better than to hide and snuggle under blankets. She's not antisocial; she just likes to keep warm. She loves it when her name is called and is always ready to receive attention.

PICKLES

(*following page*) Pickles is a three-year-old fluffy black cat. She was found in a baseball field with her kittens and brought to a vet's office. When Pickles was discovered, it appeared that she had a burn mark down her back and no fur in that area. She was taken in by a rescue. Her long fur mostly covers her bald spot. Despite her rough start in life, Pickles is a very friendly and sweet cat.

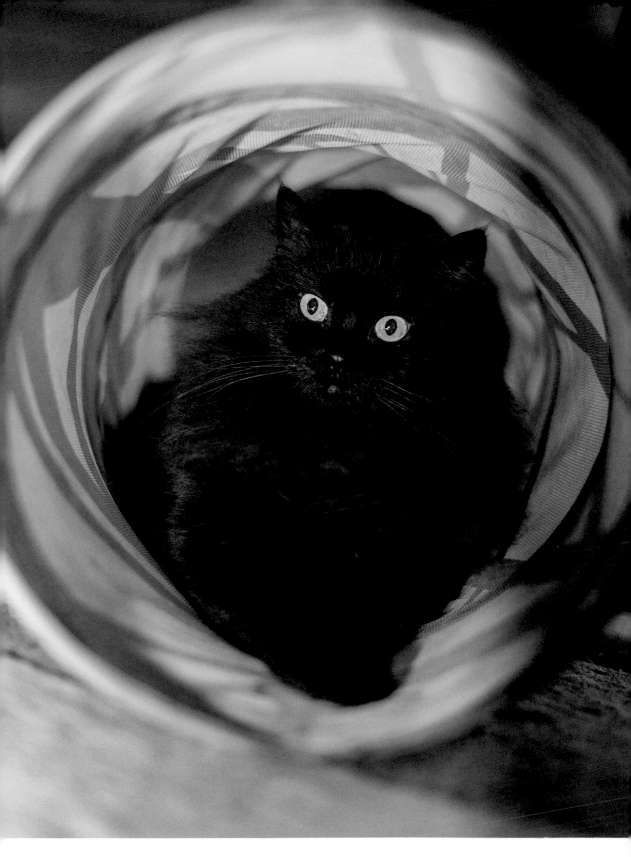

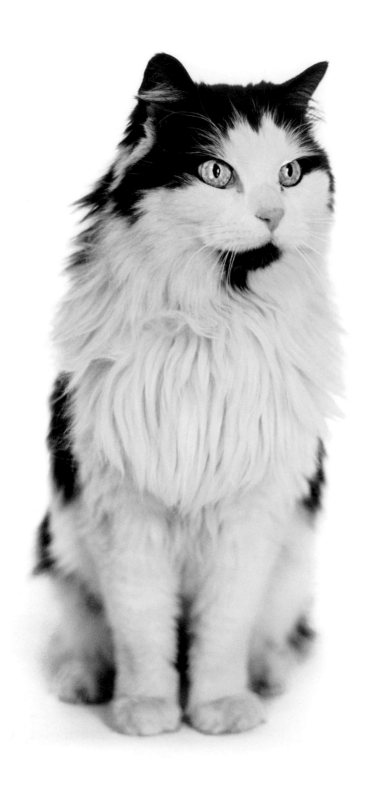

FELICIA

(*previous page*) Felicia is a beautiful long-hair kitty who was found as a stray in a shed on a rural Cincinnati-area property. The good Samaritan who found her made sure she ended up at a rescue so she could find her new home. She is approximately eight years old and is a sweet and friendly girl.

DANNI

(*above*) Danni is a gorgeous flame point or red Siamese kitty who is around three years of age. Most people are familiar with seal point Siamese cats, those with the characteristic dark-brown fur and even darker points (ears, legs, tail, and face), but Siamese cats come in all different colors. Danni is a little shy around people, but that didn't stop this sweet girl from being adopted into a loving home.

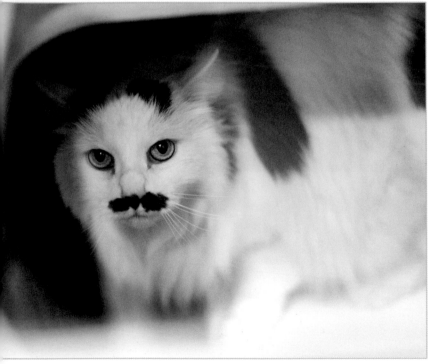

CLUE

(top and bottom) Clue is a kitty bewildered by her new life in a rescue. She is six years old or so and was a happy and loved pet until her owner passed away. Clue is a kitty looking for someone to love her and fill the hole in her heart.

CONNIE

(following page) Connie is a two-year-old tabby girl who was abandoned as a kitten in a parking lot. A rescue was called, and they took her in. She has lived with a foster ever since. This little girl is curious, friendly, and loves to play with toys.

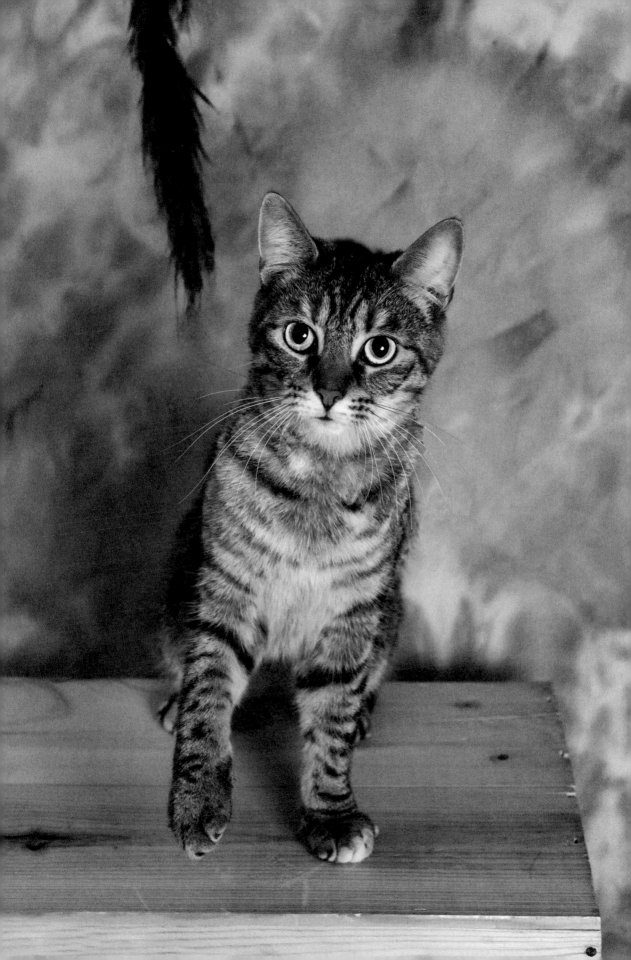

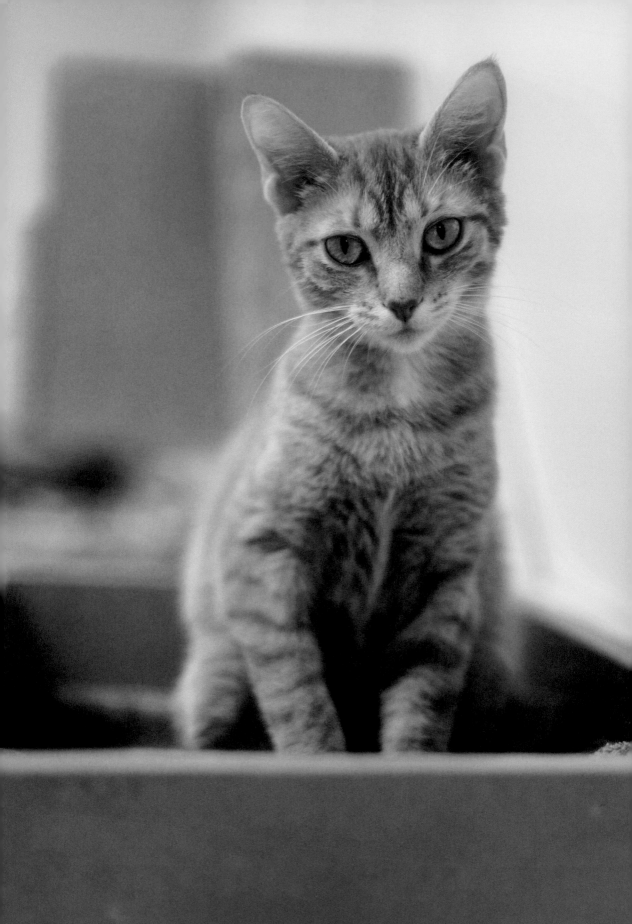

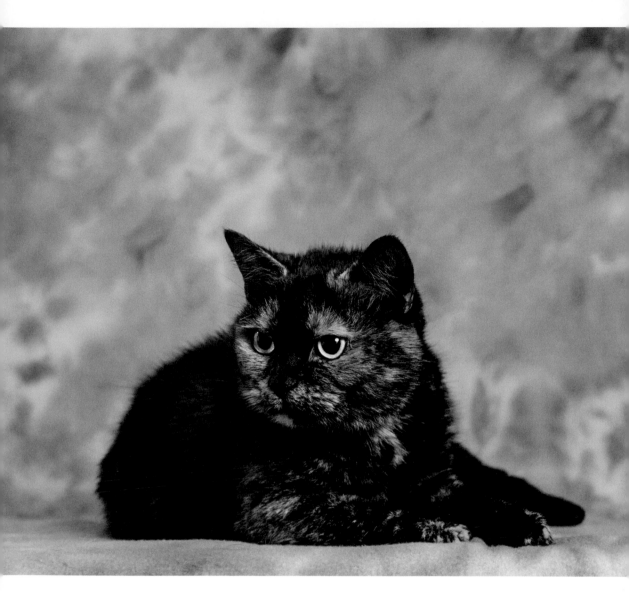

CLEMENTINE

(previous page) Clementine is a sweet and small orange tabby girl under two years old. Orange cats are most often male. It is not that common to find an orange female, as only about 20 percent of orange tabbies are female. The person who adopted Clementine from a no-kill shelter knew what a rare find they had with this sweet and friendly girl.

DELLA

(above) Della was found as a stray hiding out in a retail business during a bitterly cold week. She was brought into a rescue to have a chance at finding a safe, warm, and loving home. She is a tortoiseshell kitty around five years of age. She is a very sweet girl who loves to be carried around.

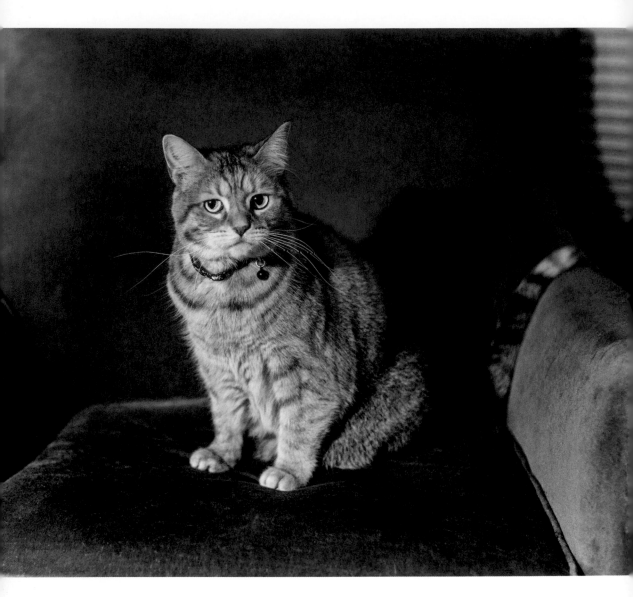

SAMANTHA

Samantha, a torbie cat, is approximately six years old. She
was adopted out as a kitten to a home with a small child,
but it was a disastrous relationship and Samantha (then
known as Patty) was returned to the rescue. When she was
almost a year old, she was adopted out to an older couple.
The couple's dog picked Samantha out at the pet store
adoption center. Samantha loves to play with toys, but her
favorite toy is her doggy brother's tail.

The couple's dog picked
Samantha out at the pet store
adoption center.

MARBLES

Marbles is a three-year-old tabby cat who was found living in a storage trailer behind a grocery store. This friendly guy was caught and taken in by a rescue where he'll get the chance to find his happy home. He loves people and adores attention.

Marbles is a three-year-old tabby cat who was found living in a storage trailer . . .

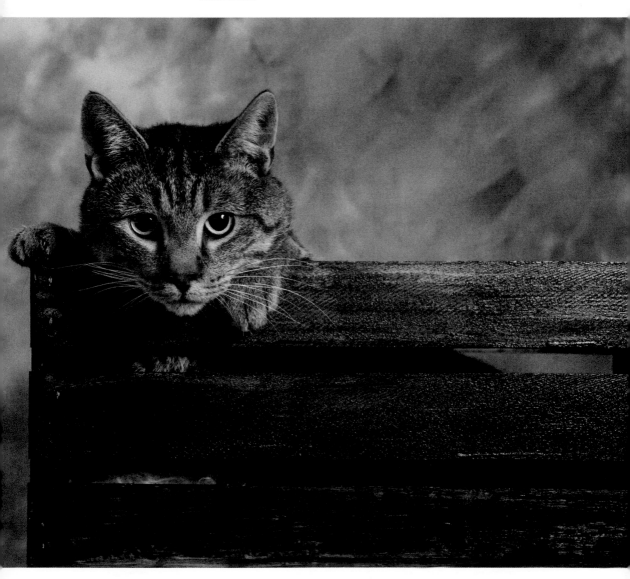

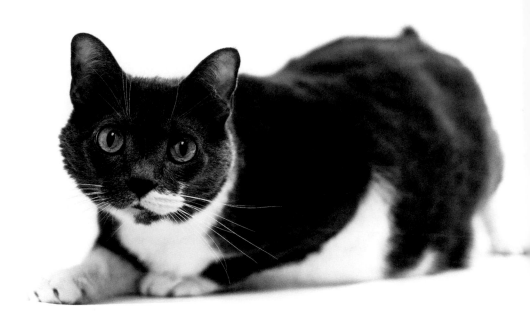

BRUISER

(*above*) Bruiser is a five-year-old gray-and-white domestic short-hair cat. He's a big guy, so his name suits him quite well. He is a shy guy with a heart full of love to give. He is bonded with his sister cat, Baby, and they were fortunate enough to be adopted together.

BABY

(*following page*) Baby, a five-year-old tortoiseshell cat, arrived in rescue with her brother, Bruiser. Though Baby loves to cuddle, she is curious, yet cautious, as any cat would be who had their world turned upside-down. Baby and her brother, a bonded pair, were adopted together.

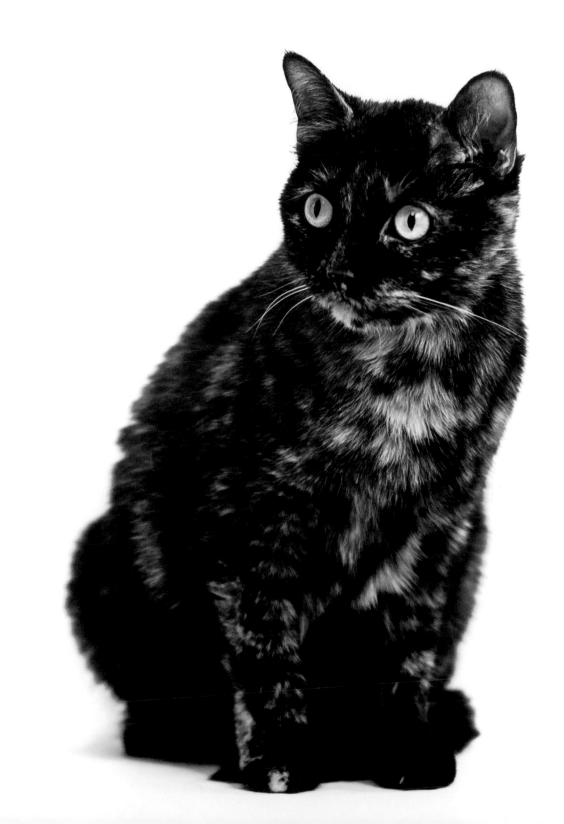

GRACIE

Gracie is a laid-back, long-haired tuxedo cat who loves to talk. She is a friendly, happy-go-lucky girl. Long-haired cats require extra grooming to keep their fur free of tangles. Gracie's fur had to be trimmed down to take care of some matting, but it grew back into a beautiful coat.

Gracie is a laid-back, long-haired tuxedo cat who loves to talk.

HORATIO

Horatio is a handsome Siamese cat roughly two years of age. He was found as a stray when he showed up at a shed on a rural property near Cincinnati. A good Samaritan took Horatio in until a rescue could take him. Horatio is your typical, talkative Siamese cat. He was quickly adopted out into a loving family.

Horatio is a handsome Siamese cat roughly two years of age.

MISSY

Missy is a gorgeous gray tabby cat with big, beautiful golden eyes. She was a fabulous mom to her three kittens (Joyce and John are featured in this book), but is done with maternal affairs. She is a talkative and demanding cat when seeking attention, but is happy to go off exploring on her own, as well. This gorgeous girl was lucky to find love and got adopted a few months after her kittens found homes of their own.

This gorgeous girl was lucky to find love and got adopted a few months after her kittens found homes of their own.

Blair, a beautiful black cat,

is a little shy until she gets

to know you.

BLAIR

Blair, a beautiful black cat, is a little shy until she gets to know you. Once she does, however, she will spend hours telling you about her day and insisting on rubs. This timid girl needed to be adopted into a home with no other cats and without small children. Fortunately, she was able to find a loving home that fit the bill.

BAILEY

Bailey is a calico cat around eight years of age. She was taken to a shelter when her owner went into an assisted living facility and could no longer care for her. Bailey is a very affectionate girl and was fortunate enough to be taken into a rescue group, from which she was subsequently adopted.

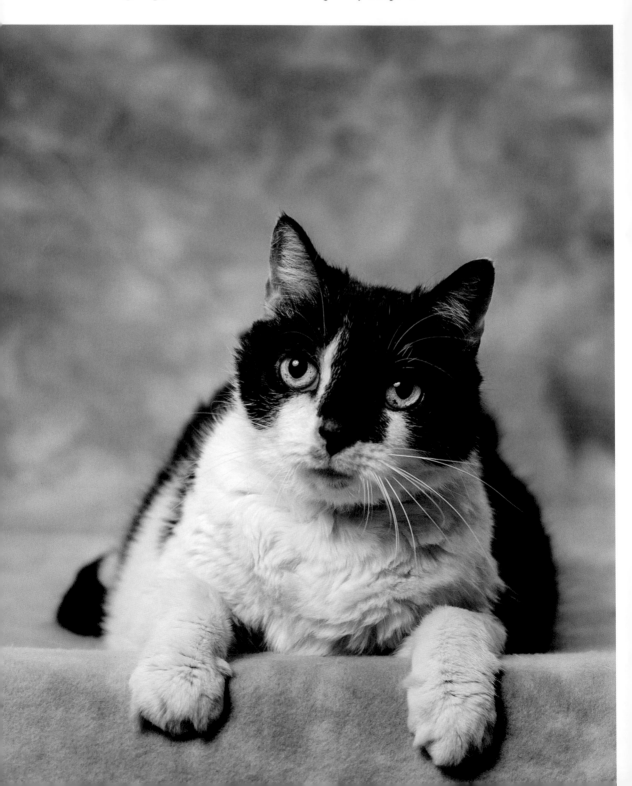

3 SENIORS

MAX

Max is a senior cat around thirteen years of age. When he was about a year old, he showed up in a residential garage. The person who found him was unable to care for him, but a neighbor, Max's future adopter, stepped in to help. Max is a bit shy with strangers. He loves to cuddle and can usually be found in his mom's lap while she works from home.

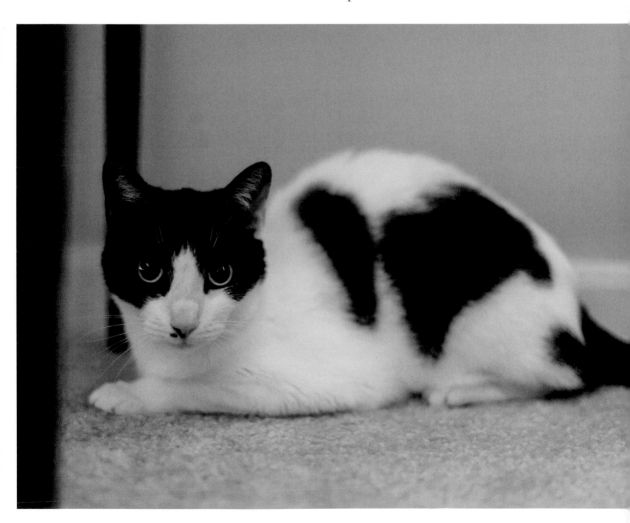

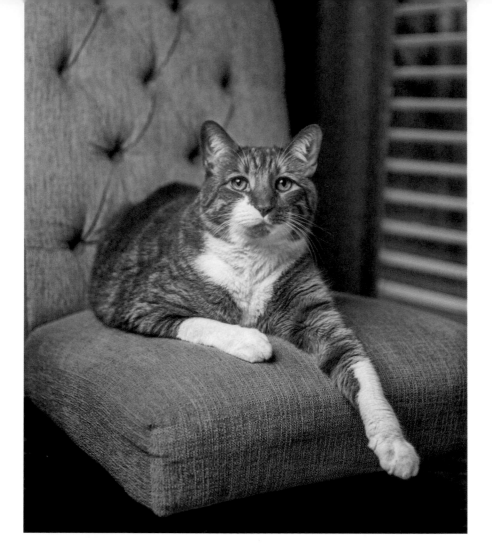

ROMEOW

The very handsome Romeow is a senior kitty somewhere between the ages of ten and twelve. He was adopted from a humane society that had the big boy (he weighed in at eighteen pounds at the time of adoption) listed as only around a year-and-a-half old. When his adoptive family took him to the vet, they were told Romeow was really five to seven years old. This sweet boy loves to both give and receive attention. He is even a therapy cat, making monthly visits to a nursing home to spend time with the residents. Romeow has slimmed down to about twelve pounds. His favorite activity is cuddling, and he gets plenty of that in his loving home, and from his friends at the nursing home.

The very handsome Romeow is a senior kitty somewhere between the ages of ten and twelve.

MOOKIE

Mookie was found as a stray when she was around one-and-a-half years old. A young girl, who was home sick from school, found her and began leaving food for her until she was able to get close enough to her to bring her into the house. Mookie was hidden in the girl's basement for three months, after which time her presence was revealed to the girl's parents. She was told she could keep her through the winter, but eleven years later, Mookie is still the young girl's (now a young adult) best friend. Mookie is a sweet kitty who loves playing with string, soaking up the sun, and playing outdoors in her family's backyard. Now thirteen years old, she remains a happy and healthy cat who is very loved.

Mookie is a sweet kitty who loves playing with string, soaking up the sun, and playing outdoors in her family's backyard.

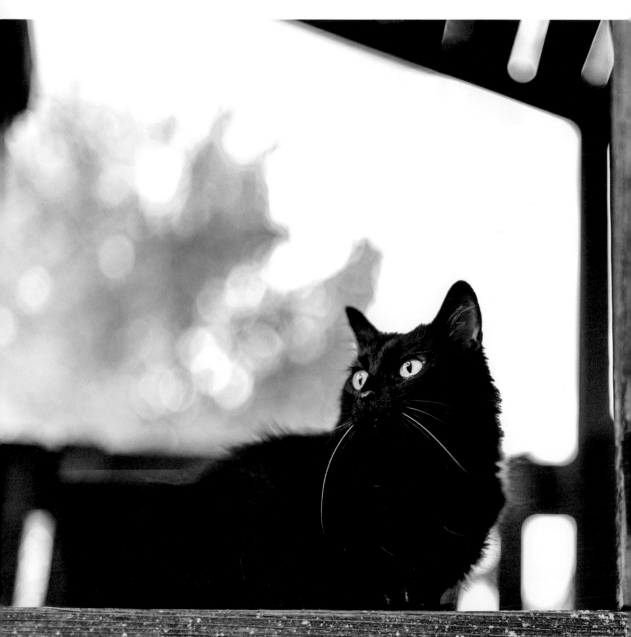

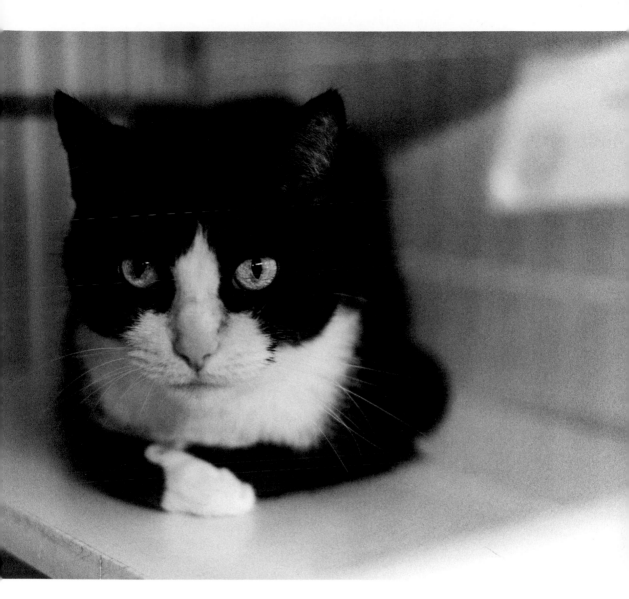

DUNKIN

Dunkin can be a little grumpy at times, but what senior lady doesn't deserve to be?

(previous page and above) Dunkin is a senior lady at ten years of age. This sweet tuxedo kitty was adored until her owner passed away. She is now lonely and in need of a lap to fill. Dunkin can be a little grumpy at times, but what senior lady doesn't deserve to be? She is looking for a home to call her own for the rest of her loving days.

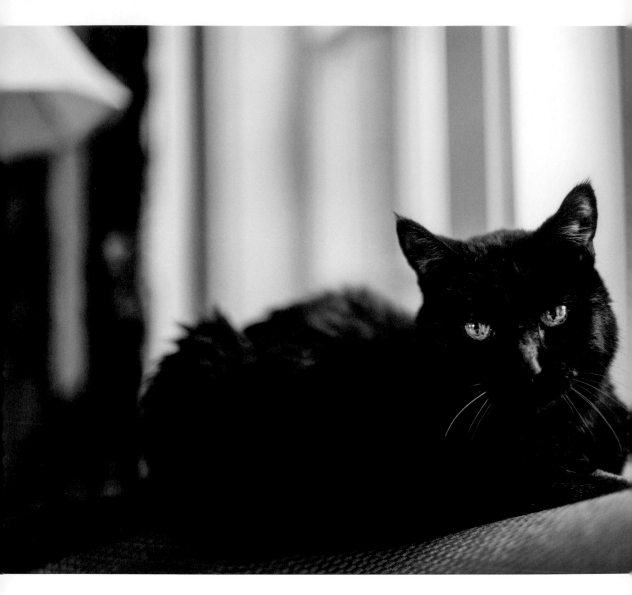

CROSBY

This handsome senior black cat was originally found on the streets as a stray at a much younger age. He was adopted into a loving home with other cats where he lived a life of luxury and leisure. Sadly, Crosby passed away in 2017 at the age of nineteen.

This handsome senior black cat was originally found on the streets as a stray . . .

VICTORIA

This beautiful fourteen-year-old long-haired tabby cat is a big girl, tipping the scales at fourteen pounds. Unfortunately, her family moved into a new home and didn't want to take Victoria with them. This beautiful and sweet senior just wants a calm, loving home to call her own.

This beautiful fourteen-year-old long-haired tabby cat is a big girl . . . at fourteen pounds.

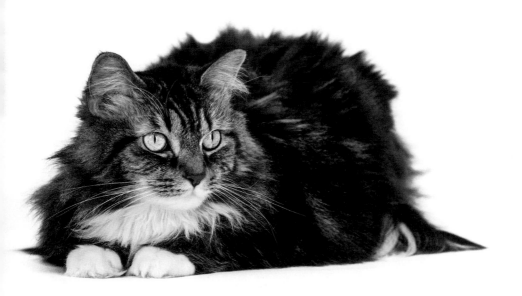

MAI TAI

Mai Tai is a senior kitty at over thirteen years of age, and she loves everyone she meets. She was found abandoned near some cabins on a lake in Kentucky. This senior lady has been at a no-kill shelter in Cincinnati since August 2015 and is still searching for a home of her own to live out her remaining years. She is part of the shelter's None Left Behind program, which means there is no adoption fee to take her home and that any existing medical expenses at the time of adoption will be covered by the shelter.

Mai Tai is a senior kitty at over thirteen years of age, and she loves everyone she meets.

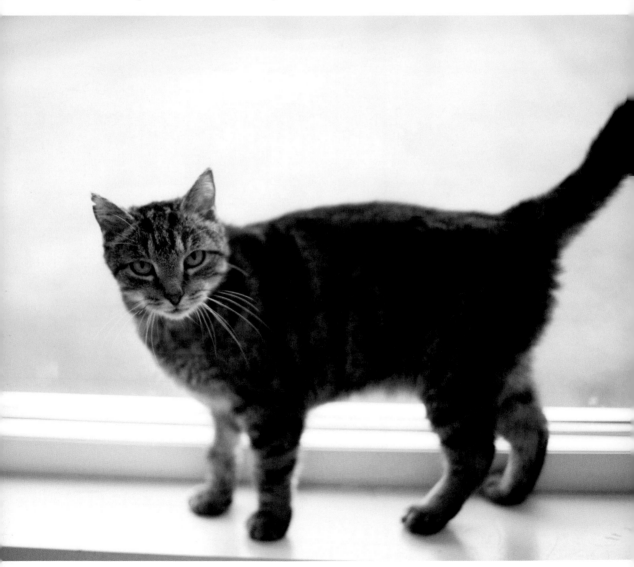

4 Special Needs

MOOMOO

MooMoo is a special cat because she never lets her disabilities get in the way. This sweet tabby girl ended up in a rescue suffering from a badly damaged leg that had healed without any treatment. Surgery was performed to remove her damaged leg, and MooMoo was able to blossom. MooMoo loves sitting in her human's lap and was lucky enough to get adopted into a household with another kitty.

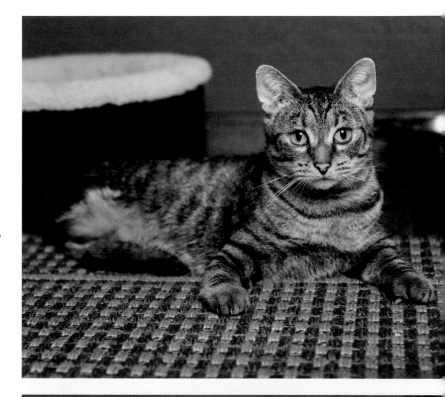

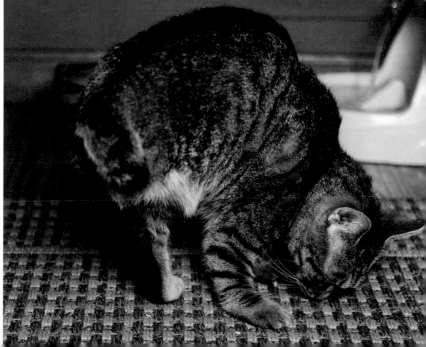

JONSON

(below) Jonson was adopted from a rescue as a tiny kitten. After a few months in his new home, he became a special needs cat for the rest of his life. He suffered from bowel problems that required frequent trips to the vet for enemas; he also had to take medicine daily to help with his issues. This adorable orange-and-white cat was very special; despite his medical problems, he maintained his sweet and friendly nature. He is pictured here as a senior, just a couple years before he passed away at nearly twelve years old.

TIGGER

(following page) Tigger, a pretty eight-year-old tabby cat was dubbed special needs due to her suffering from IBD (irritable bowel disease). Fortunately, this sweet cat found the perfect loving home to take care of her and her medical needs.

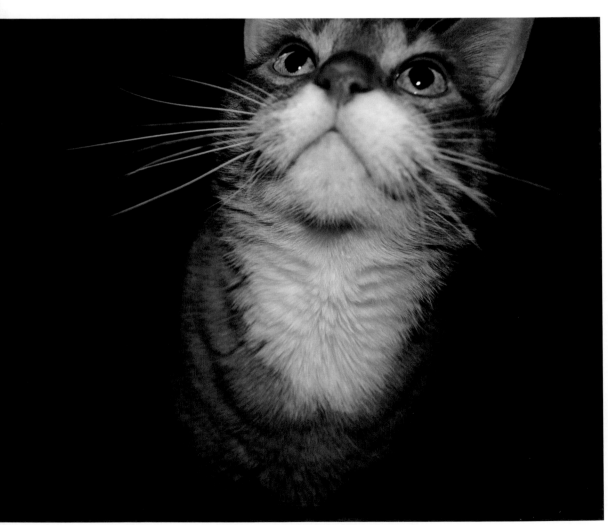

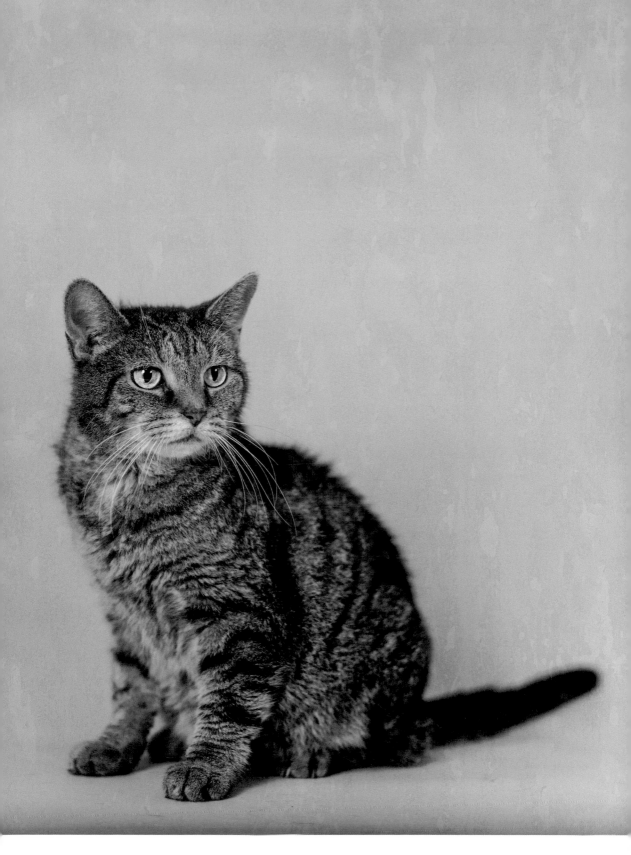

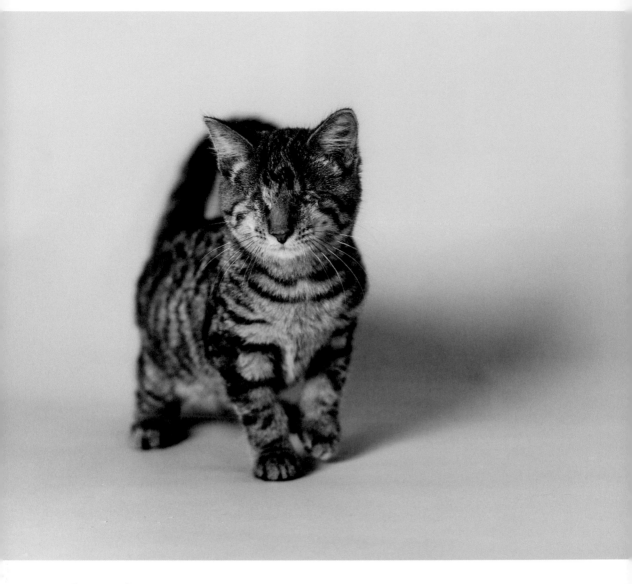

SMALLS

(above and following page) Smalls, a small adult tabby cat, had to have his eyes removed due to some trauma. However, not having sight doesn't stop this kitty from playing and having fun. Animals with disabilities can teach humans a lot, because they don't let their problems get them down. And, although they may need to make a few adjustments, they keep on with their normal behaviors.

Animals with disabilities can teach humans a lot, because they don't let their problems get them down.

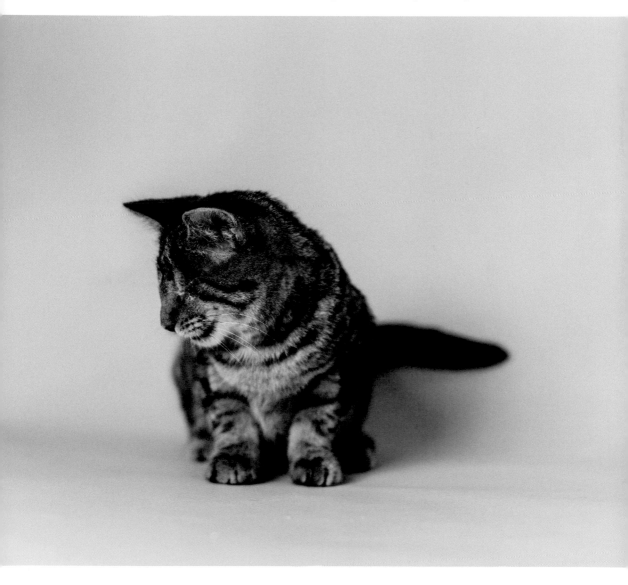

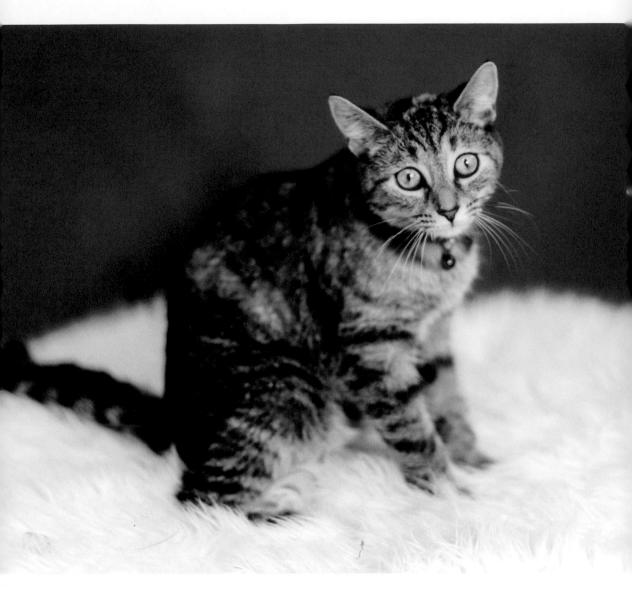

TINA

Tina, a young tabby cat, came to a small rescue with her sister. Sadly, during Tina's spay surgery, she actually died on the surgery table, but was brought back to life by the medical team. Unfortunately, Tina lost her vision and much cognitive and physical ability. She doesn't really see or walk well and is often confused by her surroundings. However, she is still a sweet and loving kitty who will remain under the care of the rescue, where she can get the medical attention she needs for the rest of her life.

Sadly, during Tina's spay surgery, she actually died on the surgery table, but was brought back to life by the medical team.

STITCH

Stitch is a young female
dilute calico . . .

Stitch is a young female dilute calico who had kittens at some point in her young life. She was found as a stray with some trauma to her left eye. While it looks a little odd, she can still see out of it. She is a unique and sweet kitty.

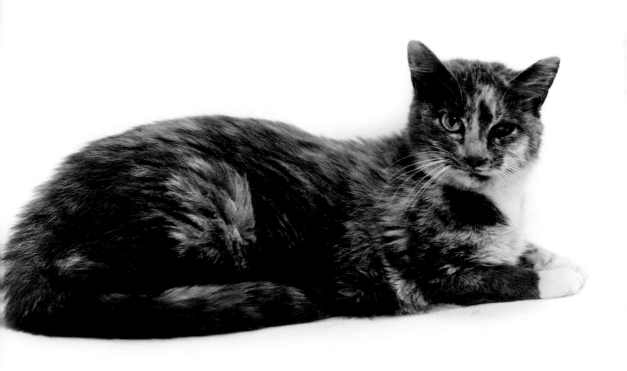

LEONARD

(previous page, this page)
Leonard is both a senior and a special needs cat. At the ripe old age of twelve, this guy still has a lot of love to give. Leonard is a happy cat who loves to have visitors. He went from being a stray to living in a traditional shelter and ended up at a no-kill shelter.

Leonard is FIV positive. FIV is Feline Immunodeficiency Virus, which is an AIDS-like syndrome. FIV-positive cats can live long and mostly healthy lives. They can also successfully live with non-FIV positive cats, as the disease is usually only transmitted through bites received during aggressive fighting. FIV can only be transmitted from one cat to another and is not transmitted to humans or other animals.

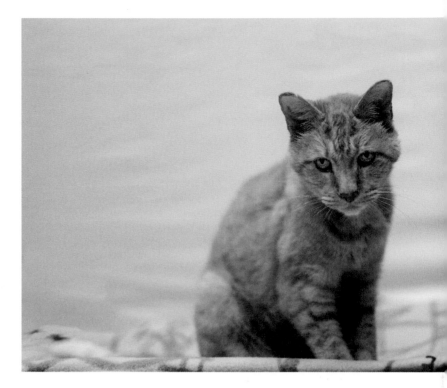

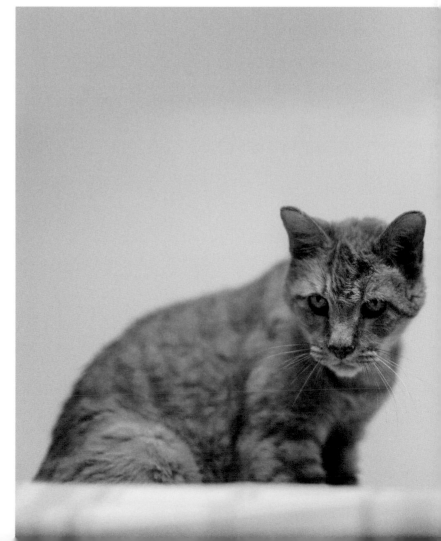

TOMMY

Tommy is head of security at Pets In Need of Greater Cincinnati. Shortly after his picture was taken, he had one of his back legs amputated because of vaccine-site sarcoma. Having only three legs hasn't stopped Tommy from performing his duties, and he's the fastest thing on three legs the clinic staff has ever seen!

Having only three legs hasn't stopped Tommy from performing his duties . . .

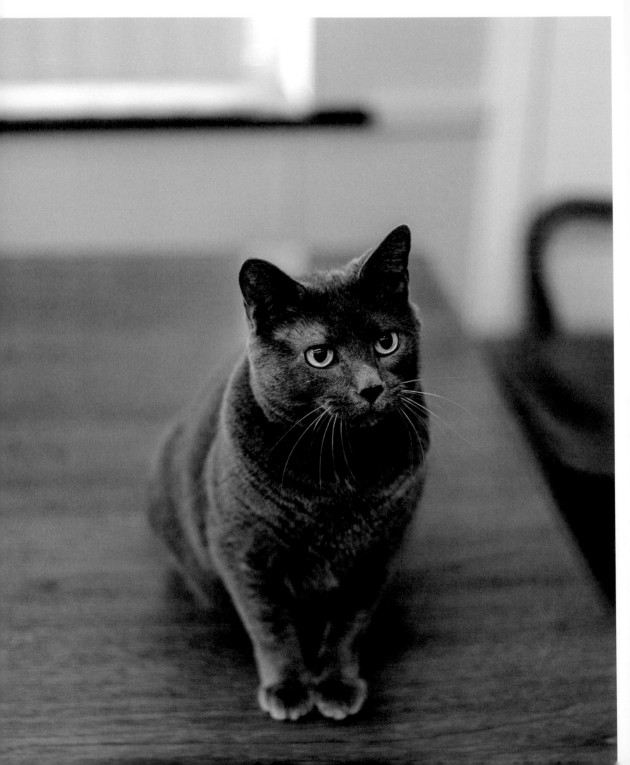

INDEX